# The Boutonniere,
## Style in One's Lapel

# The Boutonniere
## Style

# in One's Lapel

Umberto Angeloni of Brioni

Introduction by Richard Martin

Essays by Sir Roy Strong, Nick Foulkes, and Umberto Angeloni

Additional commentary by Colin Woodhead

First published in the United States of America in 2000 by
UNIVERSE PUBLISHING
A Division of Rizzoli International Publications, Inc.
300 Park Avenue South
New York, NY 10010

Copyright © 2000 Universe Publishing

Front cover photo: Moviestore Collection

Back cover photo: Robert Levin

00 01 02/10 9 8 7 6 5 4 3 2 1

ISBN: 0-7893-0388-4

Printed and bound in Singapore

# Acknowledgments

I have always been an occasional wearer of buttonholes at weddings and gala events and sometimes at country parties, where I pick something suitable from the garden.

Then, one day, while looking for cufflinks in an antique shop, I found a vintage silver flower-holder, something I had never seen before, and I realized that there might be a world of history and beauty behind an art which has practically disappeared from our culture.

In 1995, as I was in London to finalize a book on James Bond, I explained my idea to Nick Foulkes, who thought it was "brilliant." He subsequently suggested that we should invite Sir Roy Strong to delve into the relationship between men and flowers over the centuries, while Nick himself would write about the "golden age" of the boutonniere. I decided to go ahead with the project, to research and write the contemporary part of the story myself, and to include suggestions on how to revive the fashion of wearing boutonnieres.

At the time, I did not expect that this task would prove to be so complicated. There were no resources from which to draw an overall picture of the subject, no collective know-how. In fact, there was very little to go on at all, but I discovered there was genuine interest in the subject. Every journalist and magazine editor I spoke to was fascinated by the idea of the book, and many friends and colleagues began to look around for potential information and imagery.

Finally, after three years, I have not only developed a passion for the subject but have also collected enough evidence to construct a theory and to illustrate my own personal vision.

As I wait for the first copy of this book, I think of the people who understood my vision and would like to thank them for all their help. Three people deserve particular thanks: Colin Woodhead shadowed my ideas throughout the project, helped me bring them all together, and wrote all the captions—themselves a story within a story; Joe Barrato tastefully helped select and coordinate the wardrobe of the "how-to" images; and Marci Sutin Levin devised an inspired promotional strategy to bring this unique and, I hope, intriguing book to a wider audience.

This endeavor, I also trust, will underscore the importance of sartorial elegance in our daily lives, imbuing modern man with a natural grace and civility that has defined style through the ages.

I dedicate all this work to my three sons, whom I hope will understand my interest and share my enthusiasm for the revival of an almost lost art.

# Introduction &

## Men and Flowers

### 26

### The
### of

### The Bou

### the

### The Well-Dre

# A Modern
# Manual 64

History 12

Great Age
the Boutonniere
onniere in
Modern Day 40
ssed Lapel:

# Introduction

RICHARD MARTIN

In all truth, I am a most unlikely candidate to write the introduction to this unusual and marvelous book. I am almost certainly the only one of its contributors who has never actually worn a boutonniere outside of full-dress formal occasions. Well, not never, actually. I do seem to recall a moment long ago—I must have been about six—when I did try to sport one.

I was in Ocean City, New Jersey; it was the first night of our family's annual summer vacation, which lasted some five weeks. I remember that my brother and I had been left alone in our hotel room to dress for dinner. Even then, I had somehow intuited the iconic power of the boutonniere, and I believed that I was ready to be a bona fide boutonniere boy. Having proudly splayed out my new summer suits on my bed (Richard Gere would go on to re-create this scene in *American Gigolo*, but to less effect), I acknowledged to myself that this would be a very important summer for my wardrobe. It was my "mixed" summer—some suits with short pants (which, in the presence of older sophisticates I liked to call my "bermudas"), some with long pants.

I asked my brother to help me select a suit for the first night's dinner. He suggested a pristine, navy-striped seersucker, and I concurred. None of my little suits had buttonholes in their lapels, but being a bit of a visionary, I had already engineered a plan to circumvent that problem. Indeed, ever since spring, I had entertained a vision of myself as a boutonniere man strolling on the boardwalk that summer. And if Philadelphia or Ocean City were not ready for this fashion breakthrough, a six-year-old Richard Martin certainly was. In my mind, it was a perfectly natural decision: boardwalk, skee-ball, cotton candy . . . boutonniere.

The preparations had been made months before in Philadelphia. Foreseeing the covert actions I might need to take in Ocean City that summer, and very eager to do my own tailoring, I had secretly assembled a kit consisting of scissors, pin, and needle—the essential tools I would need to rectify the problem of the absent, or at best insufficent, buttonhole on my little suit coats. The tailoring, I knew, would have to be done entirely on my own, as seeking my mother's aid would have ruined the requisite sense of adventure and self-determination.

Thrilled that I knew how to manipulate the manicure scissors pilfered for this purpose, I had nonetheless forgotten that I did not even know how to initiate a hole in a fabric. Not surprisingly, then, after ten sweaty minutes (air-conditioning

being wholly dependent on the fickle sea breeze) I was nearly in tears asking my brother to help me pin the limp flower, procured on that afternoon's walk, to what was now a considerably mottled, crumpled, and altogether roiled lapel that had been not only poked and perspired upon but also slashed at several points by curved scissors designed for fingernail clipping. I should also add that, with all the anxiety, the jacket had become slightly soiled as well, as the handy needle-for-flower-pin had managed to puncture one of my fingers, leading me to daub blood on every surface I touched.

I was yet very proud. I was convinced I looked grand, if a little rumpled. But when I presented myself on the hotel's front porch, where my parents were waiting for us to come down to dinner, I knew from the minute my mother's eyes met the front of my suit that I was not the prince of the summer season both she and I had envisioned. Rather, I had once again become the mischievous and all too familiar Huck Finn of seasons past. Yet I continued to feel pretty smart and proud, even imagining myself as Adolphe Monjou or Fred Astaire, until I saw the darkening look in my mother's eyes. It was at that moment, standing on the front porch of the Hotel Alvyn, when I realized that, despite my passion, I was not destined to be a man for the boutonniere.

Still, I can't help but think that perhaps my instinct had been keenly correct, just premature. I still blame my older brother, who never displayed more than a pro forma interest in the task; he must have already discerned the benefit of being seen as the better brother of the evening. After a perfunctory "How could you have let him do this?" his punishment was over, and I was to remain the evening's sole abomination. My boutonniere idea had been a disaster: a child's suit unnecessarily marred and a first night of vacation ruined. I can still vividly recall that early summer evening under the awning of the hotel's porch: my wanting to be so proud and yet feeling so imprudent and foolish—a shame perhaps intensified by a particularly bourgeois upbringing. I may have lost the dream of the elegant boutonniere man that evening, but it is this very dream that I have found anew in this book.

As the essays by Sir Roy Strong and Nick Foulkes will amply demonstrate, there is much to be said on the historical evolution of flowers in menswear. As both decoration and iconography, flowers have always adorned both the male and female forms. Sir Roy ends his story with the flower's virtual disappearance in men's dress at the beginning of the nineteenth century. Around this time, the Industrial Revolution began to assert its authority, and decoration was disavowed as a frivolous impertinence. Irrelevant to production and virtually nonexistent within the industrial city, the flower was likewise all but invisible in a man's personal appearance, associated only with the most lascivious and sensuous segments of society.

So it was with quick dispatch that flowers and frills disappeared in menswear; they were quickly replaced by somber tones and textures, hard and purposefully robust. By about 1835, as the last echoes of Beau Brummell sentiment faded, the era of the "Great Male Renunciation" had begun. Men preferred ordered, less decorative dress—a wardrobe determined by the rigors of business and the hierarchy and etiquette of the workplace. As the duality of a blue-collar/white-collar world became more and more distinct, the office worker eventually adopted what would become standard modern business attire: shirt, tie, and suit. These somber clothes inevitably took on the muted colors of the early modern industrialized city: most notably charcoal and dark blue. Adornment, of course, was eschewed.

More than a century and a half after it began, the Great Male Renunciation is, in many ways, still in effect, especially in the U.S. and England, where exuberant beauty and decorousness tend to be associated with indulgence and vanity. Male fashion usually avoids floral patterns, decorative elaboration, and unnecessary ornament. As cultural historians of late have seen it, this ongoing trend seems to be more a cultural act of suppression than the result of any natural predisposition on the part of men.

It is thus all the more satisfying that this book, after nearly fifty years, has allowed me to retrieve my besmirched dignity and renew my love of the boutonniere, which I can now regard with a refreshed gaze and a new-found admiration. With the sartorial wisdom contained in this book, I can be a boutonniere boy all over again, and this time, I can do it right.

And if God can forgive my brother a few suave sins, then perhaps he will forgive me the childhood folly that so tried my mother's patience. I also hope that he might see fit to grant me one small vanity: when the flowing robes are being handed out at heaven's gate, I ask only that he try to get me one with a proper buttonhole in the lapel.

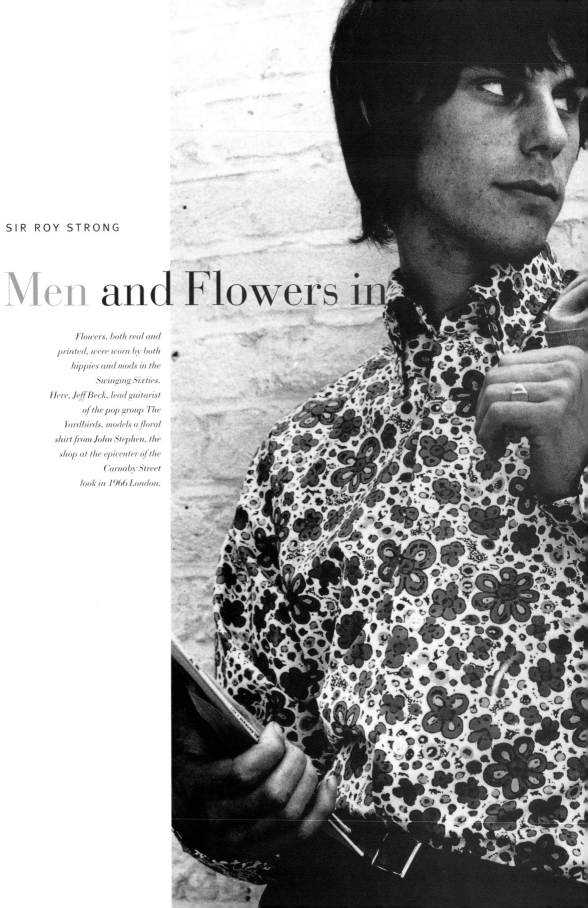

SIR ROY STRONG

# Men and Flowers in

*Flowers, both real and printed, were worn by both hippies and mods in the Swinging Sixties. Here, Jeff Beck, lead guitarist of the pop group The Yardbirds, models a floral shirt from John Stephen, the shop at the epicenter of the Carnaby Street look in 1966 London.*

On March 4, 1969, I went to the premier of the film *Isadora* and wrote of the occasion in my diary: "The invitation bade those who came to wear 'gems and flowers.' Mark Lancaster and David Hockney in green, both appeared wearing garlands of flowers, and Patrick Procktor wore a bouquet of enameled ones in his lapel."

History

Here in one small tableau was the sexual revolution of the twentieth century manifested in new styles of dress that deliberately transgressed the historical guidelines established to define masculinity in clothes since the French Revolution. The postwar generation had grown to maturity and had revolted against the dreariness of industrial society and the old establishment. Their revolution was more sexual than political, and clothes became a primary instrument of change. They looked back to the styles worn by the dandies and bohemians of the nineteenth century, and the result was an explosion of male sartorial display that remains unequaled in any other part of the twentieth century. There seemed to be no limits; men adopted frilled and ruffled shirts, velvet jackets in the regency style, and wide belts on hip-hugging trousers. Anything truly floral had until then been more or less the exclusive domain of women. The sight of men in shirts and ties, let alone jackets and caftans, covered in flowers crossed established boundaries. With the exception of the Hawaiian holiday shirt born in the 1940s, flowers had been acceptable only as part of the discreet formalized patterns on gentlemen's ties and then only when accompanying an equally discreet dark suit. Now, thanks to the impulses of the liberated sixties, male dress was feminized.

But what of flowers in men's dress in the preceding centuries? Even that phantasmagorical sartorial fling of the sixties had to have roots somewhere. The "flower power" bride and groom in virgin white, their heads garlanded for their nuptials, was no innovation. When Charles VIII of France entered Naples in 1494, the ladies of the city wreathed his head with a chaplet of violets, which he accepted without hesitation, his masculinity apparently still intact. If we look at Albrecht Dürer's great altarpiece *The Feast of the Rose Garlands,* we see men crowned with rose garlands to mark their membership in the Confraternity of the Rosary. In the foreground kneels Emperor Maximilian I, his head encircled by a rosy diadem, as the pope receives his own from the Christ child.

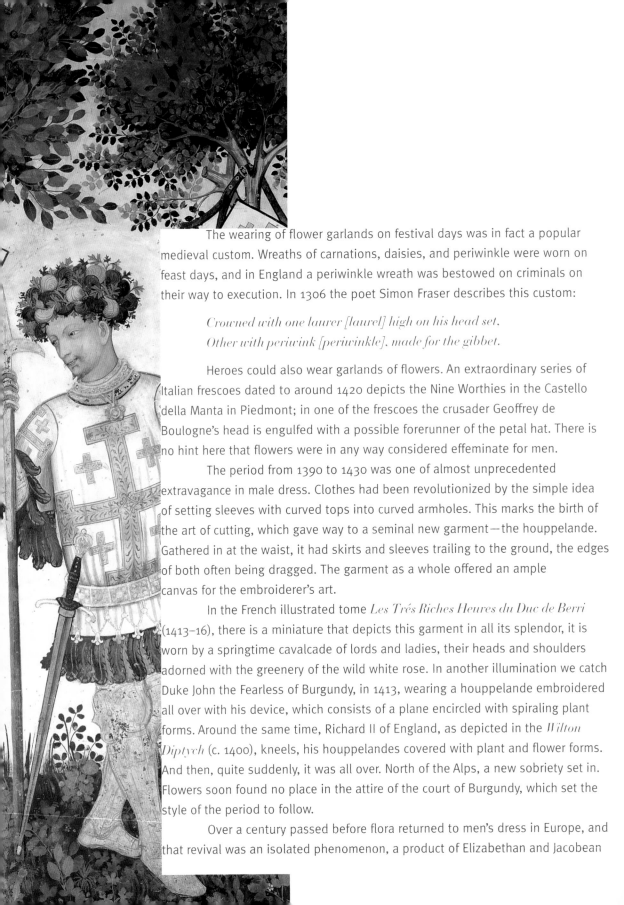

The wearing of flower garlands on festival days was in fact a popular medieval custom. Wreaths of carnations, daisies, and periwinkle were worn on feast days, and in England a periwinkle wreath was bestowed on criminals on their way to execution. In 1306 the poet Simon Fraser describes this custom:

*Crowned with one laurer [laurel] high on his head set,*
*Other with periwink [periwinkle], made for the gibbet.*

Heroes could also wear garlands of flowers. An extraordinary series of Italian frescoes dated to around 1420 depicts the Nine Worthies in the Castello della Manta in Piedmont; in one of the frescoes the crusader Geoffrey de Boulogne's head is engulfed with a possible forerunner of the petal hat. There is no hint here that flowers were in any way considered effeminate for men.

The period from 1390 to 1430 was one of almost unprecedented extravagance in male dress. Clothes had been revolutionized by the simple idea of setting sleeves with curved tops into curved armholes. This marks the birth of the art of cutting, which gave way to a seminal new garment—the houppelande. Gathered in at the waist, it had skirts and sleeves trailing to the ground, the edges of both often being dragged. The garment as a whole offered an ample canvas for the embroiderer's art.

In the French illustrated tome *Les Trés Riches Heures du Duc de Berri* (1413–16), there is a miniature that depicts this garment in all its splendor, it is worn by a springtime cavalcade of lords and ladies, their heads and shoulders adorned with the greenery of the wild white rose. In another illumination we catch Duke John the Fearless of Burgundy, in 1413, wearing a houppelande embroidered all over with his device, which consists of a plane encircled with spiraling plant forms. Around the same time, Richard II of England, as depicted in the *Wilton Diptych* (c. 1400), kneels, his houppelandes covered with plant and flower forms. And then, quite suddenly, it was all over. North of the Alps, a new sobriety set in. Flowers soon found no place in the attire of the court of Burgundy, which set the style of the period to follow.

Over a century passed before flora returned to men's dress in Europe, and that revival was an isolated phenomenon, a product of Elizabethan and Jacobean

The period from 1390 to 1430 was one of almost unprecdented extravagance in male dress. Clothes had been revolutionized by the simple idea of setting sleeves with curved tops into curved armholes.

England, where there occurred a unique renaissance of the embroiderer's art, one that would find no counterpart on the continent, however. Undoubtedly the most spectacular exemplars of this phenomenon were the costumes worn by Richard and Edward Sackville, the third and fourth earls of Dorset, respectively. Two large paintings, both dated 1613, capture these prodigal aristocrats almost certainly as they appeared at the wedding of James I's daughter, Elizabeth, to the elector Pala-tine. The event occasioned extravagant dress on an almost unprecedented scale. The third Lord Dorset's outfit consists of a doublet of silver cloth embroidered all over with honeysuckle flowers in black and gold. His trunk hose repeat the motif, but in reverse; the floral pattern can be seen on the earl's gauntlets. The fourth lord's clothes are not quite so fantastic, but nonetheless are embroidered all over with red roses and pansies.

Gloves, like handkerchiefs, were symbols of status and part of the full dress of anyone of rank. In an era when clothes were a reflection of social hierar-chy, garments were richly adorned, often with huge garlands thickly embroidered with nature motifs that usually included flowers. In some circumstances, floral fea-tures could also have an emblematic connotation. A miniature portrait of Robert Devereux, second earl of Essex, who was Queen Elizabeth's last favorite, depicts him attired for the great tournament, held annually on the Queen's Accession Day, November 17. The queen's glove is tied to the earl's arm by a silken scarf, and the skirts he wears over his armor are elaborately embroidered with his device, or impresa, which in turn is encircled by branches of eglantine, a wild white five-petalled rose. The eglantine was one of the queen's emblems, and an onlooker would no doubt interpret this flower as a compliment on the part of the earl to his queen.

Flowers in dress could be merely decoration, or they could purvey a specific meaning; specific symbolism aside, flower motifs in England during this period reflected a more general interest in the appreciation and cultivation of flowers. Large, elaborate gardens began to appear for the very first time, often with new flowers that were arriving from the Middle East and the New World.

Richly illustrated publications by William Turner, Henry Lyte, and John Gerard furnished embroiderers with ample illustrations to work from—a cornucopia

*Robert Devereux, second earl of Essex and the last favorite of Queen Elizabeth I, in a miniature of 1587, wears, over his armor, a skirt embroidered with eglantines—five-petaled wild roses that were one of the royal emblems of the period.*

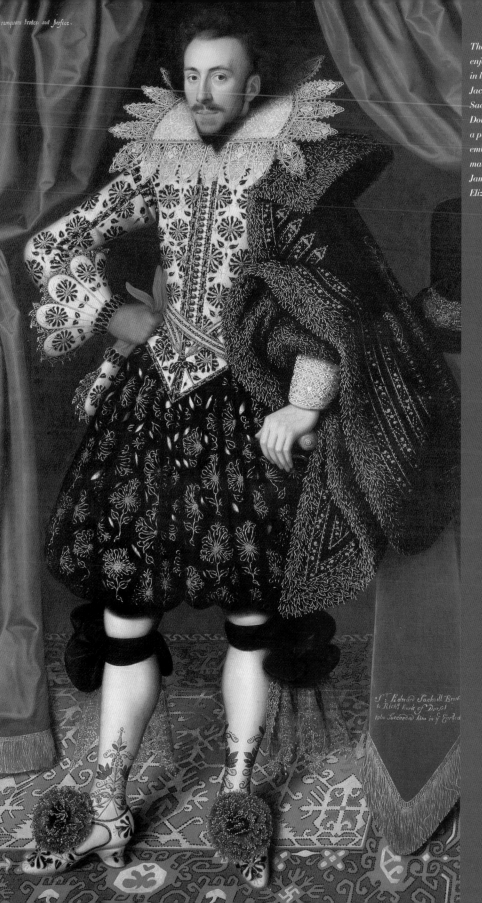

*...nunquam tendes aut perfice.*

The embroiderer's art enjoyed a unique renaissance in late Elizabethan and Jacobean England. Edward Sackville, fourth earl of Dorset, proudly stands for a portrait in the elaborately embroidered outfit he had made for the wedding of King James I's first daughter, Elizabeth, in 1613.

*opposite: Distinguished French military commander Vicomte de Turenne in 1660, in a collar fashioned from the recently-introduced Venetian lace—its floral designs were more three-dimensional and sculptural than those of the earlier, flatter Flemish bobbin lace.*

of roses, pansies, carnations, violets, irises, lilies, narcissus, cornflowers, hyacinths, tulips, and peonies. But again, as was the case during the international Gothic era of the early fifteenth century, this floral revival was short-lived. By the 1620s, ostentatious displays in men's costume had given way to the plainer styles favored in France. Widespread use of flowers in male clothing in Europe would not resurface for another century.

The new fashions that took over from the 1620s were softer and more fluid in line, making use of plain or subtly patterned silks in both somber and strong colors. However, this new style did provide an ideal ground for the display of patterns in lace, which, on men's garments, were usually seen on the falling band as ruffs went out of fashion. Collars with scalloped edges made from bobbin lace now fell broadly across men's shoulders in the cavalier style caught in the portraits by Van Dyck. The lace itself was brought over from the Spanish Netherlands, where manufacturers could respond with speed to every innovation in fashion.

While formalized pots of flowers had been used as a motif in sixteenth-century lace, it was not until the 1630s that they became a more universal motif admirably suited to these long, scalloped collars. In the two decades that followed, these wide, falling bands gave way to bib-fronted successors, and the lace designs changed accordingly. Pots of flowers were replaced by larger flower heads in which the shapes of the individual petals were clearly defined. In the 1670s and 1680s, these flower heads were placed symmetrically within a vertical arrangement of leafy stems or were enclosed by scrolling stems within a more free-flowing design.

Such lacework gave a foretaste of the baroque spirit that would find much fuller expression in Venetian needle lace, which began to dominate the European market from the mid-1650s onward. Once again, this new style was owed, in part, to a revolution in manufacturing methods, which enabled the production of bold patterns employing three-dimensional details created by over-sewing. The result was a sculptural effect, akin to that of ivory carving. The leaves and flowers in this type of lace are always clearly discernible and exactly delineated. Rich and weighty, such lace was particularly suited to the fashions of the Spanish, Italian, and German courts, where such encrusted bands and shirt cuffs

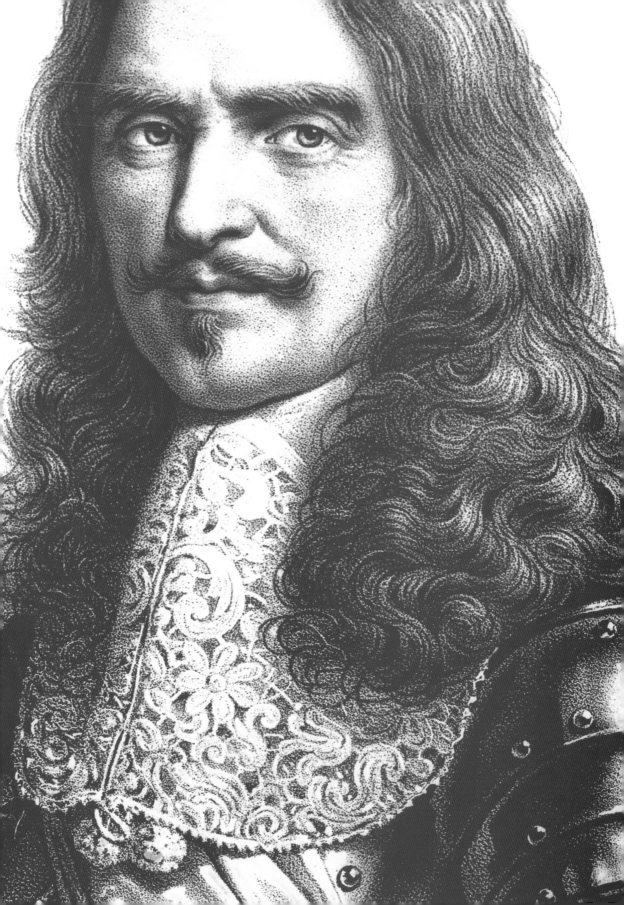

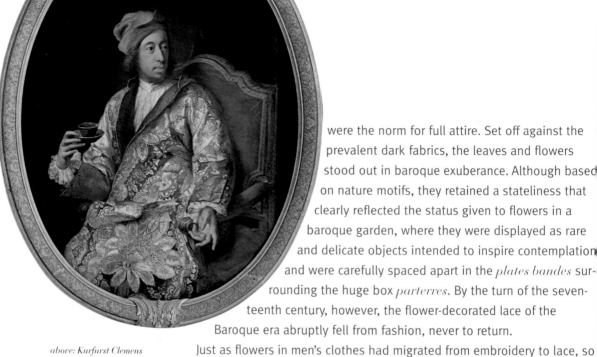

were the norm for full attire. Set off against the prevalent dark fabrics, the leaves and flowers stood out in baroque exuberance. Although based on nature motifs, they retained a stateliness that clearly reflected the status given to flowers in a baroque garden, where they were displayed as rare and delicate objects intended to inspire contemplation and were carefully spaced apart in the *plates bandes* surrounding the huge box *parterres*. By the turn of the seventeenth century, however, the flower-decorated lace of the Baroque era abruptly fell from fashion, never to return.

Just as flowers in men's clothes had migrated from embroidery to lace, so now they moved from lace to silks, which were central to fashionable male attire until the middle of the eighteenth century. Like lace, silk was a status symbol suited to an aristocratic, hierarchical society. Until the 1740s, when printed fabrics were introduced, pattern and decoration were achieved through jacquard weaving. During these years, the best silk designers and manufacturers—who were centered not in Paris or London but in Lyons in central France—attained an unsurpassed mastery of technique. In the 1720s, the baroque tradition of bizarre formalized shapes retreated to the damask ground of the fabrics, making way for a foreground lavishly decorated with gold and silver scrolls and leaves and flowers in colored silks. In the 1740s, the rococo style arrived with a flutter of flowers reflecting the advent of new varieties, a new passionate interest in botany (this being the age of the pioneering botanist Linnaeus), and the creation of new types of flower gardens very different from those of the previous century. By the early 1760s, the repertory of blooms used by the weavers shrank to encompass little more than roses, carnations, and tree patterns.

This was also the era of the waistcoat, which in its most formal state consisted of brocade, damask, satin, or colored silk and which was always heavily embroidered or patterned in gold or silver lace. In London, Anna Maria Garthwaite became the leading silk designer among the weavers based in Spitalfields. Many of her beautiful designs survive, one of which, dated 1747, was for a "silk and

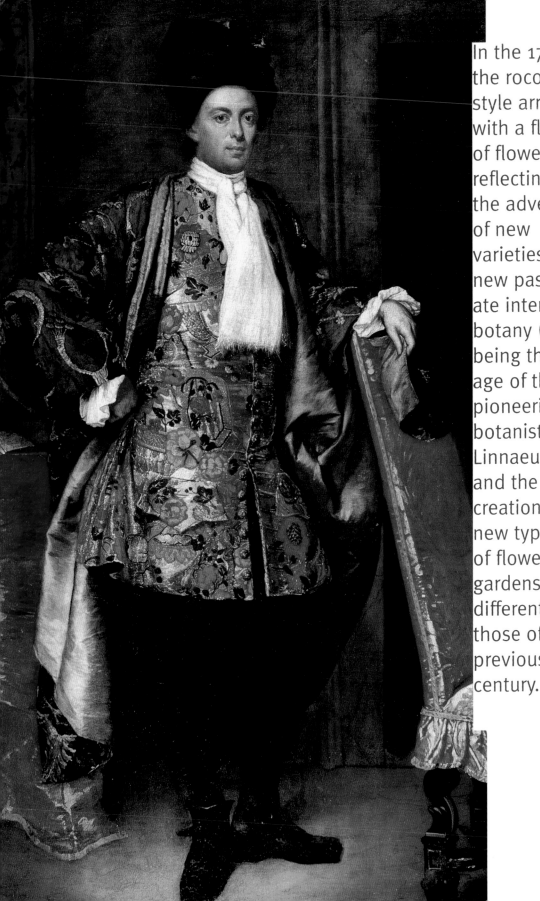

In the 1740s, the rococo style arrived with a flutter of flowers reflecting the advent of new varieties, a new passionate interest in botany (this being the age of the pioneering botanist Linnaeus), and the creation of new types of flower gardens very different from those of the previous century.

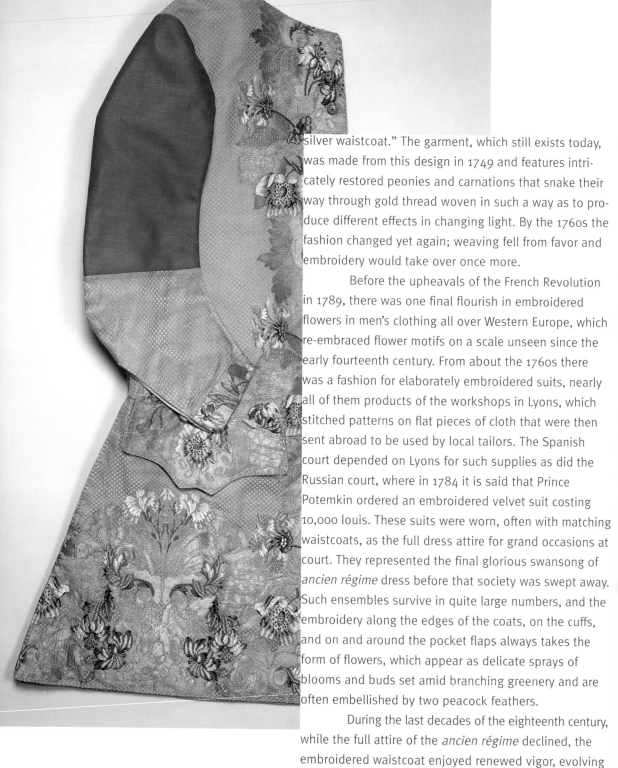

silver waistcoat." The garment, which still exists today, was made from this design in 1749 and features intricately restored peonies and carnations that snake their way through gold thread woven in such a way as to produce different effects in changing light. By the 1760s the fashion changed yet again; weaving fell from favor and embroidery would take over once more.

Before the upheavals of the French Revolution in 1789, there was one final flourish in embroidered flowers in men's clothing all over Western Europe, which re-embraced flower motifs on a scale unseen since the early fourteenth century. From about the 1760s there was a fashion for elaborately embroidered suits, nearly all of them products of the workshops in Lyons, which stitched patterns on flat pieces of cloth that were then sent abroad to be used by local tailors. The Spanish court depended on Lyons for such supplies as did the Russian court, where in 1784 it is said that Prince Potemkin ordered an embroidered velvet suit costing 10,000 louis. These suits were worn, often with matching waistcoats, as the full dress attire for grand occasions at court. They represented the final glorious swansong of *ancien régime* dress before that society was swept away. Such ensembles survive in quite large numbers, and the embroidery along the edges of the coats, on the cuffs, and on and around the pocket flaps always takes the form of flowers, which appear as delicate sprays of blooms and buds set amid branching greenery and are often embellished by two peacock feathers.

During the last decades of the eighteenth century, while the full attire of the *ancien régime* declined, the embroidered waistcoat enjoyed renewed vigor, evolving

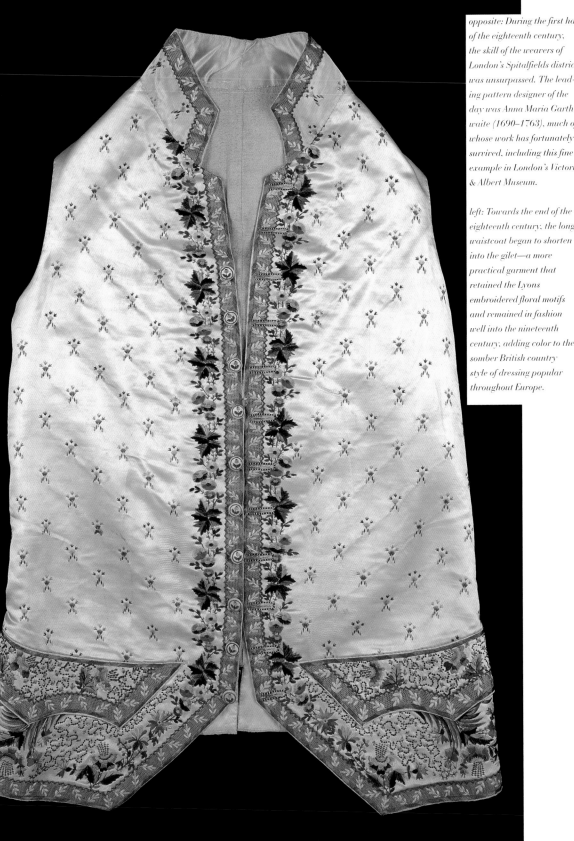

from its long-skirted form into the abbreviated one called a *gilet*. The *gilet* was invariably made of white silk and was always embroidered. The style took off in the 1780s, when it was adopted by Louis XVI, and survived the revolution, because it could also be worn with yet another less showy style of dress associated with the renewed sentiment for nature, the cult of antiquity, and the influence of the philosophes, which effectively brought an end to the vivid colors and flamboyant floral motifs fashionable earlier in the century. The new *gilet*, with its delicately sprigged embroidered flower motifs, could be worn easily with the new more practical and restrained style favored by the less flamboyant English aristocracy, particularly on their country estates.

After 1789 men began to express their status in life not just by the understatement of their clothes but increasingly through attention to tailoring. By 1815, the peacock-embroidered suits of pre-revolutionary Europe already seemed as remote as the clothes of the pre-1914 courts are to us in our own century. Flowers, beyond a token appearance in formalized patterns on neckties, not only vanished from male dress, but they were henceforth considered appropriate only for womenswear. That assumption went unchallenged until the middle of the 1960s.

Styles of fashion vanish only to return, and it remains anyone's guess as to when and how flowers will bloom once again on the male persona.

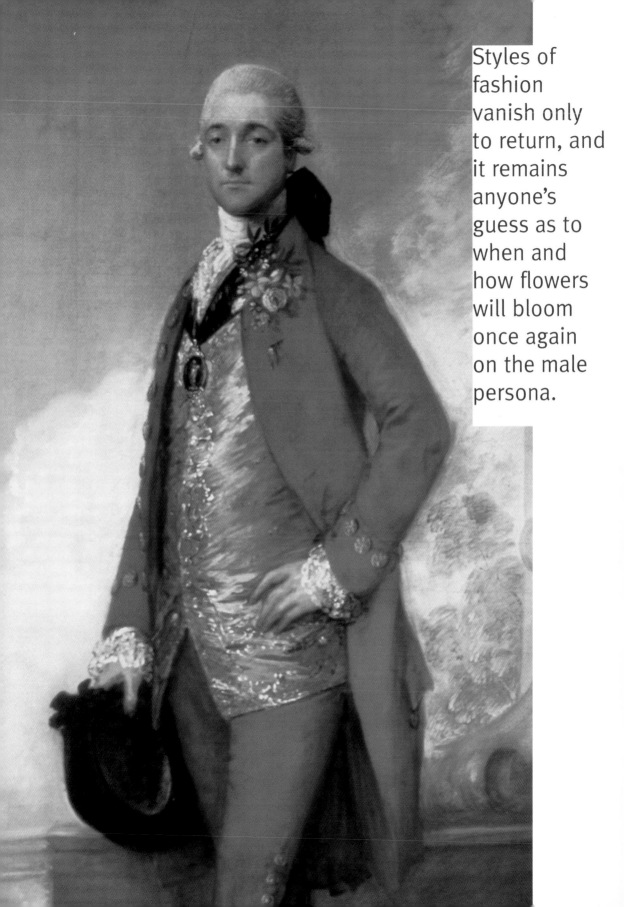

Styles of fashion vanish only to return, and it remains anyone's guess as to when and how flowers will bloom once again on the male persona.

NICK FOULKES

# The Great Age of the

*A famous exponent of*
*Roman style was*
*Gabriele D'Annunzio*
*(1863–1938), a poet,*
*dramatist, journalist,*
*soldier, womanizer, and,*
*above all, a dandy.*

History does not say which inspired genius or fashion-conscious rebel it was who first decided to leave the top buttons of his frock coat unfastened. Whoever it was, this anonymous figure is owed a huge debt by fashionable society.

# Boutonniere

The frock coat emerged as the preeminent male garment sometime after 1730 and can reasonably be said to have served as the foundation of polite dress for men until the latter half of the nineteenth century. It was originally worn as a country coat, either double or single breasted, with a turned-down collar. Little by little it came to be adopted as standard garb by sporting English gentlemen and eventually became acceptable in much of Europe as fashionable wear in all but the most formal circumstances. Indeed, the ensemble of the sporting English gentleman—boots, breeches and frock coat—was soon adopted by the French, who came to know the frock coat as a *redingote* (a bastardization of "riding coat").

In the England of the 1760s, a dandified clique of young men popularly known as "Macaronis"—after the pasta they would have eaten on their cultural tours of Italy—added further refinements to the male dress of the day. If nothing else, it seems travel certainly broadened their wardrobes.

They wore striped suits and stockings, towering wigs topped with Lilliputian tricorn hats, and shoes with oversized buckles. From the top buttonholes of their frock coats sprouted large nosegays of flowers. It was toward the close of the eighteenth century that it became fashionable to leave the top buttons of frock coats unfastened, allowing the front parts of the coat to fall back and form what later formally became the lapel.

Soon, the dandified exuberance of the Macaronis gave way to the polished and refined understatement of George Brummell, the celebrated fashion leader who set the style for the whole first half of the nineteenth century. His mode of dress—a frock coat, a chamois vest, and breeches during the day and a dark blue suit in the evening—was not only simpler than the elaborate style worn by the *beaux* of the early eighteenth century, but it would also prove more fitting for the revolution in travel soon to be brought about by the steam age.

Men's clothing had now entered a far more sober phase, where virtually all latent peacock instincts had to be curtailed, save for the fortunate opportunity proffered by the emergent lapel and its as yet unused but still retained buttonhole. It proved to be the perfect backdrop for that one last splash of color—the boutonniere—or buttonhole flower—which soon came into fashion, born on the spirit of the Romantic age and its worship of nature.

This enthusiasm for nature continued well into the 1830s, with boutonnieres taking on a symbolic—almost quasi-religious—importance in certain circles. As Farid Chenoune writes in his *History of Men's Fashion*, "The story of the boutonniere also includes its discreet rivalry with honorific ribbons and rosettes." Barbery d'Aurevilly also saw fit to allude to this new fashion in 1838, when he declared himself "Knight of the Order of Springtime." "I sacrifice a rose each evening to my buttonhole," he said, "roses are the Order of the Garter of that Great Monarch called Nature."

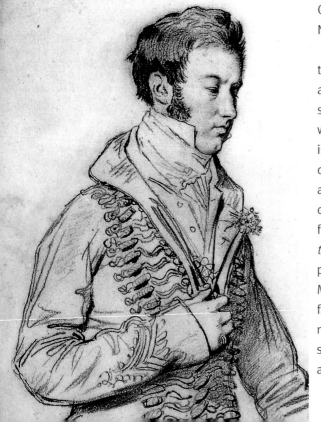

Toward the end of the nineteenth century, the boutonniere was widely accepted as the mark of a man who was careful in his dress. A man would select a fresh boutonniere in much the same way he would wear a freshly laundered shirt or a pair of polished shoes. Even that most austere of nineteenth-century British politicians William Ewart Gladstone—a statesman, orator, and four times prime minister—did not feel himself properly dressed without a flower in his buttonhole. In 1887 *The Tailor and Cutter* felt moved to record Gladstone's appearance for posterity: "It may interest my readers to know how Mr. Gladstone looked last week, when he made his famous speech against the Coercion Bill. He wore a new black frock coat, a low-buttoning waistcoat, showing a large expanse of shirt front, which is now as well known a ceremonial uniform as the wig and

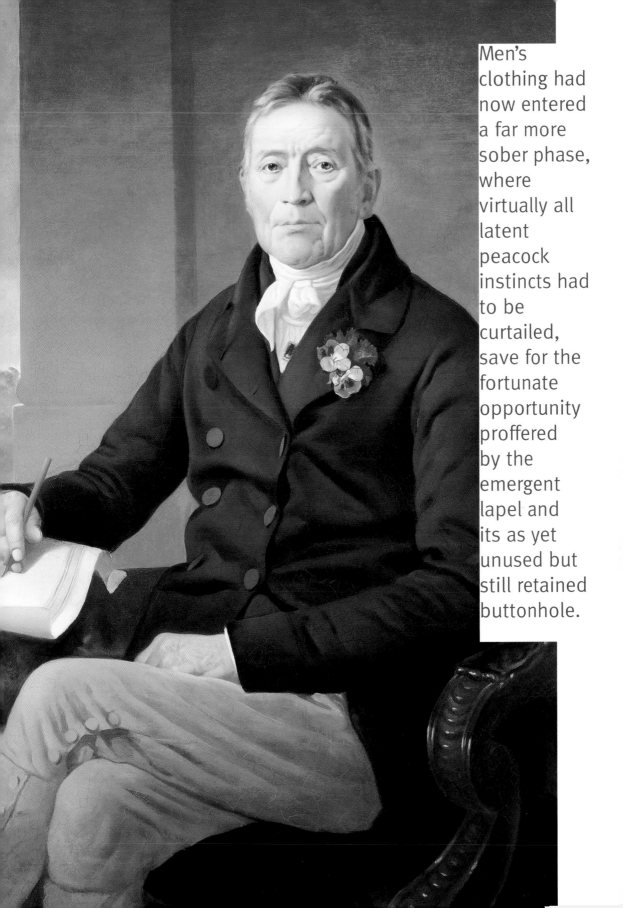

Men's clothing had now entered a far more sober phase, where virtually all latent peacock instincts had to be curtailed, save for the fortunate opportunity proffered by the emergent lapel and its as yet unused but still retained buttonhole.

gown of the Lord Chancellor; and in his buttonhole was a rose, which is also part of his full dress attire. His large white linen collar, of which the comic papers never omit a caricature, contrasted with his ashen countenance, and gave him the appearance of quite the old man."

On the other side of the English Channel, The Prince de Sagan, the man who dictated what was worn in French society in the late nineteenth century and who once memorably declared, *"Le monde c'est moi"* (I am fashionable society), was photographed by Nadar wearing a carnation in the lapel of his frock coat.

A flower worn in the buttonhole had become the apex of sartorial achievement in an era when men really did dress. Its glory lay in its fragility; it was picked, worn in the buttonhole, and allowed to die.

The flower was now definitively added to the list of preferred male accouterments of the day, including cigar cases, watch chains, jeweled pins, and fancy shirts. There were even miniature vases or flasks that were worn behind the lapel to allow the stems of the fragile bloom to stay fresh through the day or night.

Not surprisingly, wearing an exotic bloom became something of a status symbol and, depending on the choice of flowers, demonstrated variously the wearer's daring, decadence, or erudition. For instance, William Powell Frith's panoramic 1881 canvas *The Private View of the Royal Academy* shows Oscar Wilde sporting a spectacular boutonniere. And in the work of Wilde himself, the eponymous anti-hero of *The Portrait of Dorian Gray* sports a Parma violet in his buttonhole. Soon, the boutonniere took on iconic, if sometimes ominous, proportions. In an article written for *Elle* in 1992, Farid Chenoune wrote, "In the wake of Oscar Wilde's Dorian Gray, the 'decadents' made the Parma violet one of the most refined emblems of what has been called the 'mauve peril,' the great turn-of-the-century homosexual upsurge."

Indeed, the boutonniere reached its zenith around the turn of the century as Maurice de Waleffe confirms in *Quand Paris était un paradis*, in which he recalls "polished fops with black-and-white checked trousers, white spats, pocket handkerchief matching the suit, with cream-colored gloves, and a carnation in the buttonhole."

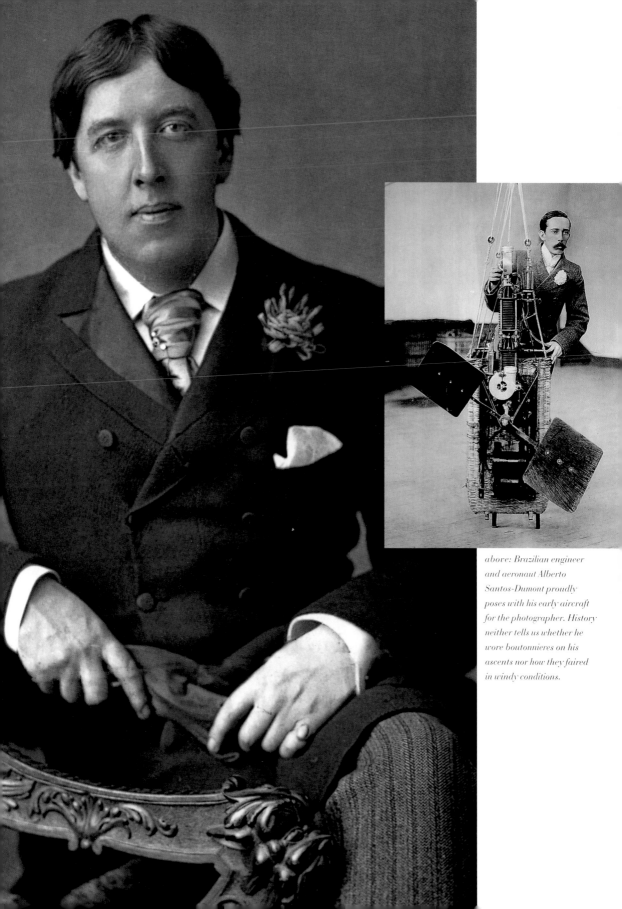

*above: Brazilian engineer and aeronaut Alberto Santos-Dumont proudly poses with his early aircraft for the photographer. History neither tells us whether he wore boutonnieres on his ascents nor how they faired in windy conditions.*

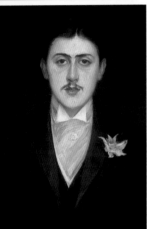

A mere decade later, hundreds of thousands of young men would be slaughtered in the trenches of the First World War. Yet despite the horrors of those years, the idea of the buttonhole somehow survived. In fact, the British soldiers marching through the poppy fields of Flanders picked the flowers and wore them in their battledress tunics. Today in Britain those same young men are remembered by the wearing of poppies in the lapel on Remembrance Day—a tradition inspired by a poem penned by a Canadian, Colonel John McRea, during a lull in the second battle of Ypres. It begins thus:

> *In Flanders fields the poppies blow*
> *Between the crosses row on row.*

The poem was sent anonymously to *Punch* magazine, where it was published immediately and caught the attention of an American, Miss Moina Michael. Miss Michael wrote a reply to the poem and, after the war, persuaded ex-servicemen to adopt the poppy as an emblem of remembrance. Artificial linen poppies were made in the devastated areas of France and the proceeds of their sale given to benefit the needy. Then, in August 1921, a French woman named Madame Guerin happened to show one of these artificial poppies to the general secretary of the British legion, who ordered one-and-a-half million of the flowers for what would henceforth be known as Poppy Day.

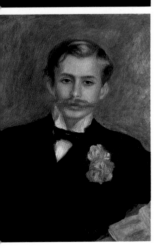

The delicate poppies aside, the hard-edged, chromium-plated, self-consciously modern world that emerged after the Great War had little room for the foppish and excessively dandified manner of the prewar years. Boutonnieres were still worn, but they lacked the exuberance and effervescence of earlier years.

After World War II, the fortunes of the buttonhole revived a little as the neo-Edwardian look of the early fifties recalled some of the glamour of the Belle Époque. It was at about this time that Norman Hallsey started working in Savile Row at Anderson & Sheppard, tailors to that great boutonniere-wearer the Duke of Windsor, among others. "The wearing of buttonholes was very common when I first came here in 1952. Men dressed up more then and mainly wore clove carnations as buttonholes," recalls Hallsey. In fact, boutonnieres were worn so regularly around this time that society florist Moyses Stevens used to prepare a board of

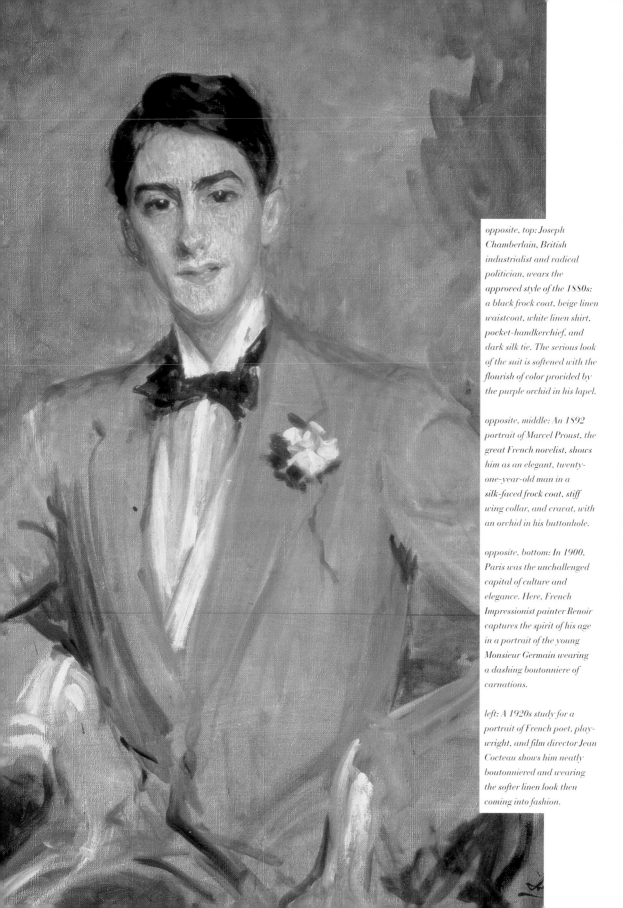

*opposite, top: Joseph Chamberlain, British industrialist and radical politician, wears the approved style of the 1880s: a black frock coat, beige linen waistcoat, white linen shirt, pocket-handkerchief, and dark silk tie. The serious look of the suit is softened with the flourish of color provided by the purple orchid in his lapel.*

*opposite, middle: An 1892 portrait of Marcel Proust, the great French novelist, shows him as an elegant, twenty-one-year-old man in a silk-faced frock coat, stiff wing collar, and cravat, with an orchid in his buttonhole.*

*opposite, bottom: In 1900, Paris was the unchallenged capital of culture and elegance. Here, French Impressionist painter Renoir captures the spirit of his age in a portrait of the young Monsieur Germain wearing a dashing boutonniere of carnations.*

*left: A 1920s study for a portrait of French poet, play-wright, and film director Jean Cocteau shows him neatly boutonniered and wearing the softer linen look then coming into fashion.*

ready-made boutonnieres for sale every morning. One style of boutonniere that became popular during the 1950s was the Malmaison carnation, which is in fact composed of three carnations that have been carefully disassembled and then reassembled as one bloom to create a veritable cauliflower of a boutonniere.

The Malmaison carnation would certainly have suited the style of Nubar Gulbenkian, an Armenian oil tycoon who used to go around town in a wicker-sided, chauffeur-driven London taxi. The fabulously rich Gulbenkian provided a welcome splash of color in drab postwar London and became perhaps the most spectacular buttonhole wearer of recent years. It can hardly have been a coincidence that when he visited Europe during the Second World War to organize escape routes for British citizens he used the code name Orchid, a flower he was immensely fond of. Typical of Gulbenkian's flamboyance was the way he welcomed in the New Year of 1957: he attended an event at the Savoy Hotel sporting a purple sombrero with a matching purple orchid in his buttonhole.

Today, Moyses Stevens no longer has a board of ready-made boutonnieres awaiting his customers, and while all the best tailors still carefully sew buttonholes into lapels with silk thread, their efforts usually go unappreciated. There are now a mere handful of occasions when buttonholes are worn. Weddings, of course, see an abundance of carnations. Occasionally a red button carnation might be seen with a dinner jacket and, now and again, a white one with full evening dress. Once in a while, during the English summer season, boutonnieres make an appearance, most noticeably in the lapels of morning coats at Royal Ascot, when a cornflower is traditionally worn. To be sure, affixing a boutonniere to one's lapel is the simplest and most modest of pleasures, and yet it is one that today requires a confidence and flair that has become as rare and elusive as an exotic flower.

To be sure, affixing a boutonniere to one's lapel is the simplest and most modest of pleasures, and yet it is one that today requires a confidence and flair that has become as rare and elusive as an exotic flower.

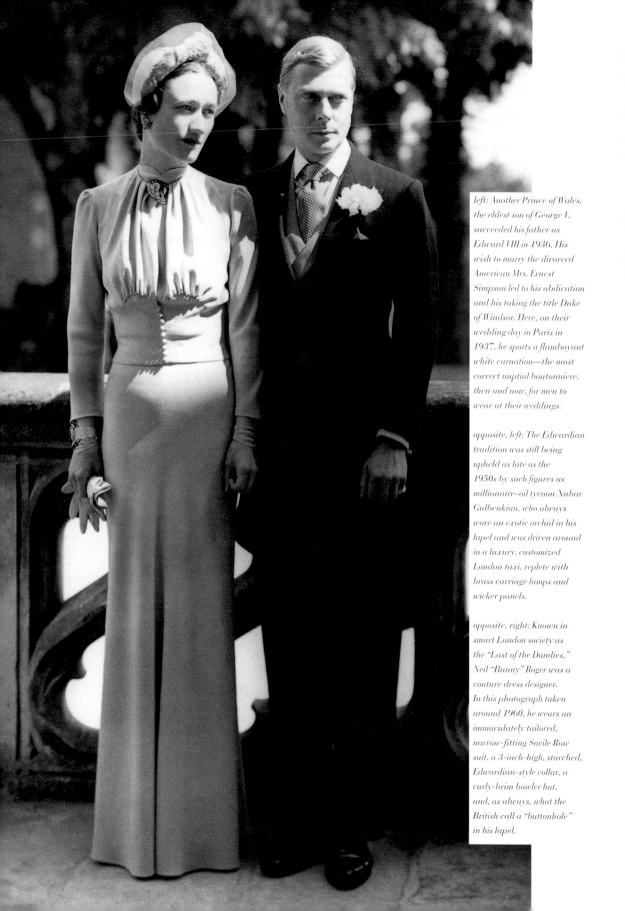

*left: Another Prince of Wales, the eldest son of George V, succeeded his father as Edward VIII in 1936. His wish to marry the divorced American Mrs. Ernest Simpson led to his abdication and his taking the title Duke of Windsor. Here, on their wedding day in Paris in 1937, he sports a flamboyant white carnation—the most correct nuptial boutonniere, then and now, for men to wear at their weddings.*

*opposite, left: The Edwardian tradition was still being upheld as late as the 1950s by such figures as millionaire–oil tycoon Nubar Gulbenkian, who always wore an exotic orchid in his lapel and was driven around in a luxury, customized London taxi, replete with brass carriage lamps and wicker panels.*

*opposite, right: Known in smart London society as the "Last of the Dandies," Neil "Bunny" Roger was a couture dress designer. In this photograph taken around 1960, he wears an immaculately tailored, narrow-fitting Savile Row suit, a 3-inch-high, starched, Edwardian-style collar, a curly-brim bowler hat, and, as always, what the British call a "buttonhole" in his lapel.*

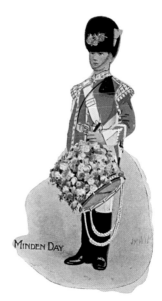

Minden Day

# Ceremonial and Symbolic

With the exception, perhaps, of Oscar Wilde's green carnation, men wearing flowers and flower motifs rarely carries effeminate connotations. Especially not among military personnel, as evidenced by some of their jealously guarded customs.

One such custom is the large bunches of shamrocks the Irish Guards wear every St. Patrick's Day. It is an honor awarded to them and the regimental mascot by Queen Victoria for bravery in Africa during the nineteenth century.

Each year, France and Britain commemorate the fallen of the World Wars at the eleventh hour of the eleventh day of the eleventh month, November. The chosen symbol is the Flanders poppy, which is re-created in silk or linen and worn in remembrance of the young men who marched through fields full of these summer flowers on their way to the front.

The Chelsea Pensioners, army veterans who live at the Royal Hospital in London, wear oak leaves every year to honor their founder, King Charles II, who, as a young man, sought refuge in an oak tree to escape from the parliamentary forces after his defeat at the Battle of Worcester.

If green plants and tree leaves can be worn on ceremonial occasions, the Welsh Guards go one better and wear vegetables. Every March 1, on St. David's Day, they wear a leek along with red dragons and daffodils, one of the principality's national symbols. With the exception of this enthusiastic man (at top left), wearing an actual leek, roots included, the soldiers, the veterans in civilian clothes, and their colonel-in-chief, the Prince of Wales, now wear paper replicas.

Real flowers as well as symbolic decorations are also part of the military tradition. Every year, five British fusilier regiments still celebrate their resounding victory at the Battle of Minden—a significant battle, in 1759, of the Seven Years War—where they had all paused briefly to cut roses from the briars through which they were advancing to engage the French. On August 1, veterans march through their hometowns to the beat of drums, holding flags, wearing berets, and sporting red, primrose-yellow, and white flowers on their lapels.

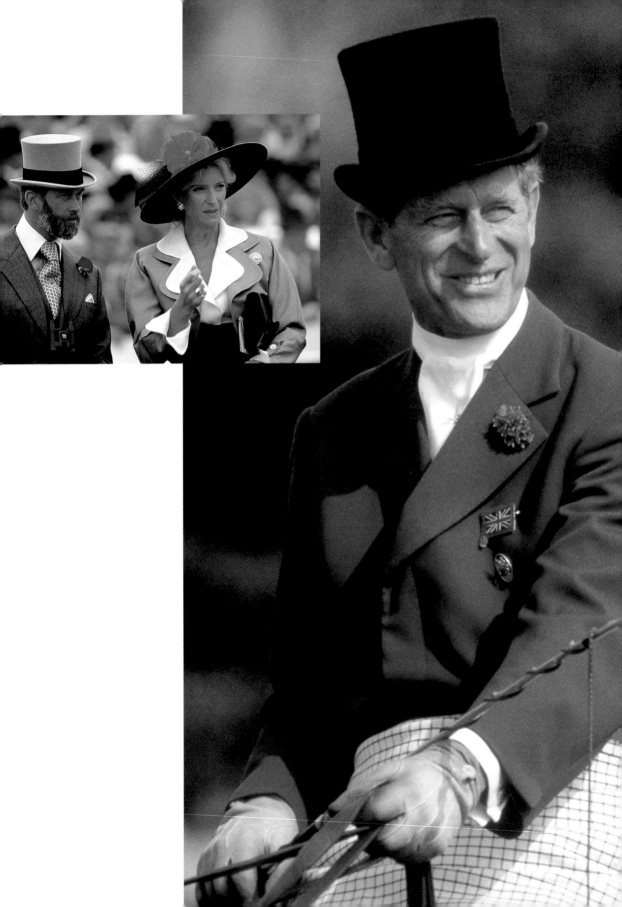

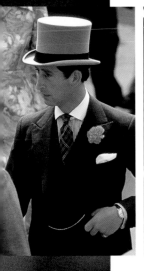  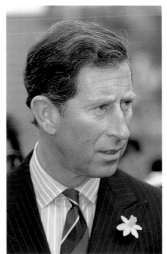 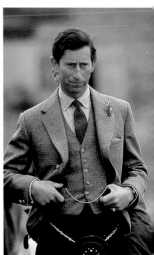

# The Royal Boutonniere

One of the duties of the royal families that have been retained by otherwise democratic European countries is, perhaps, to preserve the best of their country's traditions and to keep them safely out of reach of short-term and partisan politics. No royal institution does more to keep the wearing of the boutonniere—as a sign of style and good manners—in the public eye than the British royal family.

Prince Michael of Kent wears a red carnation to complement Princess Marie-Christine's hat on Derby Day, while the Duke of Edinburgh sports a traditional blue cornflower as he competes in one of his favorite activities—four-in-hand carriage driving, whose participants wear traditional clothing.

At the Royal Ascot Race Meeting the Prince of Wales shows that you can wear a gray top hat with a black morning suit or  a black top hat with a gray morning suit. But, above all, you should wear a boutonniere—as do most of the members of the Royal Enclosure—for this event, almost the last echo of the Edwardian era.

The Prince of Wales, who is rarely seen without a discreet flower in his lapel on summer days, wears a small yellow daffodil—the national flower of Wales—on a visit to his principality.

The royal family also feels very much at home in Scotland, but like most Scots, they do not feel at home enough to try to fix the national flower, the very prickly thistle, into a buttonhole; a sprig of heather is a much friendlier choice.

UMBERTO ANGELONI

# The Boutonniere in the

*In the 1920s and 1930s leading men's stores in both Europe and the United States commissioned some of the finest artists of their day to create advertisements promoting themselves to the burgeoning—and increasingly affluent— middle classes. This poster was painted by Tom Purvis in 1928 for Austin Reed for use on the London underground; the original is now on display at the Victoria & Albert Museum.*

# Modern Day

Consider the boutonniere. Unfortunately, in these modern times, few men do. One would have to trace fashion history as far back as the forties to find men who would regularly wear a flower in the lapel of their suit or sports jacket as part of their daily wardrobe.

Still, throughout the last four decades and even well into the nineties, certain men of style have always favored a boutonniere as a final flourish—but their numbers are scarce indeed. We may have begun, however, to see a resurgence of the practice. Perhaps by carefully analyzing the factors that led to the boutonniere's demise over the years, we may learn whether the climate is right, as we enter a new millennium, for its return.

This much is clear: the cause of the boutonniere's near disappearance is the result not of a single determinant factor but, rather, a series of conjoining factors that, ultimately, were also responsible for other analogous shifts in the history of modern dress. It is important to understand that, save for cases where a boutonniere was worn as a symbol of membership in a collective group, the wearing of a flower has never been particularly widespread among men, even in the upper echelons of society, where matters of dress were paramount. Indeed, the flourish of a lapel flower has almost always been limited to a small, select group of style-conscious, dapper gentlemen. This small group, in turn, usually established the trends for a much larger and less select constituency made up of men whose personal style and sense of fashion was decidedly suspect. From this point of view, the boutonniere's ebbing popularity may be directly linked to the gradual disappearance of truly elegant men, who could serve as role models for those wishing to dress with flair and individuality.

This issue may be wider than it appears, including the dwindling number of practitioners of custom tailoring—a suit or sports jacket must have certain features built into it to suitably accommodate a boutonniere—the increasing standardization of ready-to-wear garments, and the rise of trend-driven fashion designers. These are all factors leading to the erosion of judgment among consumers. Modern-day men

have been conditioned to embrace a "uniform" rather than to choose their wardrobes based on individual taste. Certainly, the inordinate amount of travel required by many of today's professions leaves many men little time to consider their wardrobes. There is also an inexplicable, frenzied urge to dress down for leisure activities, sometimes even for work, as evidenced by the growth of casual Friday.

Stylish accessories such as walking sticks, bow ties, hats, scarves, ascots, and gloves have fallen from favor largely because wearing them properly requires careful thought, an eye for coordination, and self-confidence. It also merits reflection that out of the numerous ways of knotting a necktie, only two methods are widely practiced today. And out of the wide range of jewelry for men, only cufflinks have remained popular through the years. What passes for style and status in this era is nothing less than tragic. Rather than emphasizing the overall elegance of our dress, we too often seem concerned with demonstrating status by way of showy objects such as exclusive credit cards, flashy watches, and exotic leather belts with shiny buckles.

*In the days before both men's fashion photography and ready-to-wear clothing, custom tailors used illustrations, such as these painted by the Italian artist Luigi Tarquini for Brioni of Rome in the 1950s, to show customers the styles of the moment. The boutonniere, along with those other endangered species hats and gloves, was still de rigeur for the man about town.*

I maintain, however, that the fear of looking too effeminate has virtually nothing to do with the disappearance of the boutonniere from the modern lexicon of men's fashion. Traditionally, when a man wears a flower in his lapel, it tells an entirely different story about his personality; it reveals a refined temperament at once artistic and romantic. In addition, a lapel flower hints that its wearer is possessed of a keen imagination and elevated sensitivity.

Neither do I think that concern over destroying a living, natural object is at all relevant. No sensible, civilized person takes objection to the art of flower arranging, the joy of giving floral bouquets, or the pleasure of adorning the home with freshly cut blooms. Worn properly in a lapel, the natural life of a flower, which is brief to begin with, is hardly made shorter. Instead, I would venture to say that the habit of donning a boutonniere reveals particular sensitivity toward the environment and a desire to live in closer harmony with it.

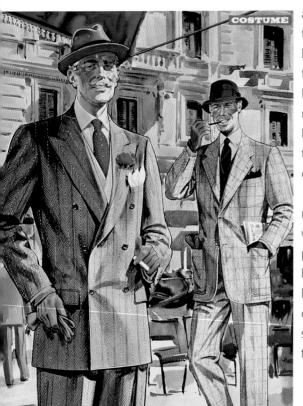

It is my theory that the evolution of the necktie may be key to the gradual decline of the practice of wearing a boutonniere. At the start of the century, flower petals had no close competition. But as tie patterns became more and more strident, color moved from the lapel to the neck, where it remains today. The tie, incidentally, made a second victim of the patterned dress shirt on the way. Looking back only half a century to those sharply etched portraits of Hollywood's leading

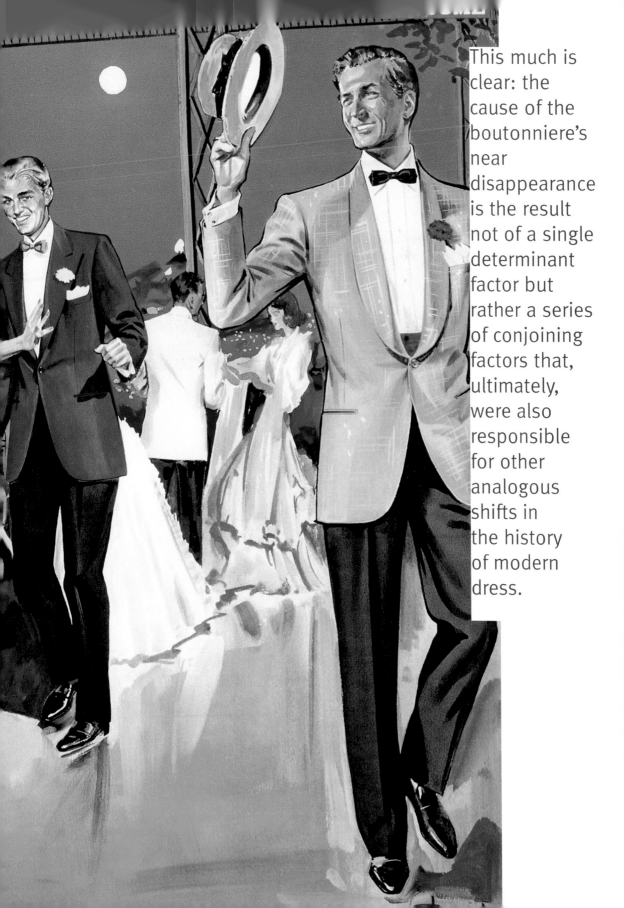

This much is clear: the cause of the boutonniere's near disappearance is the result not of a single determinant factor but rather a series of conjoining factors that, ultimately, were also responsible for other analogous shifts in the history of modern dress.

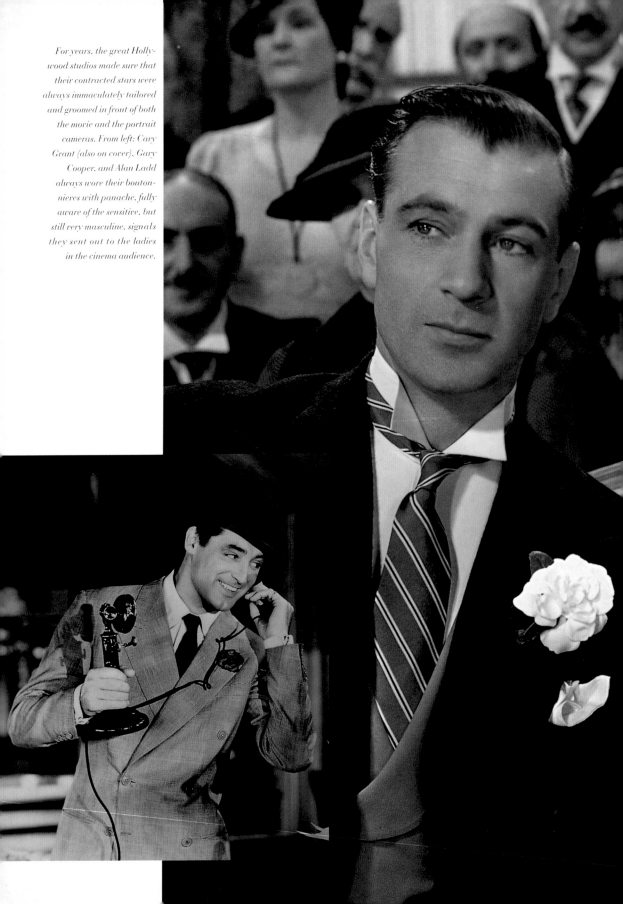

For years, the great Hollywood studios made sure that their contracted stars were always immaculately tailored and groomed in front of both the movie and the portrait cameras. From left: Cary Grant (also on cover), Gary Cooper, and Alan Ladd always wore their boutonnieres with panache, fully aware of the sensitive, but still very masculine, signals they sent out to the ladies in the cinema audience.

men reveals that boutonnieres look best—even in black-and-white photographs—with a textured suit, a plain shirt, and, at most, a tie with no more than a geometric pattern.

Having examined the reasons for the boutonniere's decline, where then do we look for signs of its possible return? First and foremost, there seems to be a universal return to elegance in men's fashion, which naturally entails a keener eye for small details. A global return to elegance, of course, is the result of a corresponding resurgence of truly elegant men—self-confident exemplars of taste, flair, and style. We can call them Renaissance men or even incurable romantics—a small fraternity of men who share the genuine pleasure of wearing a flower in the lapel. It is such a gentleman, as fashion historian Farid Chenoune writes, "whose heart feels a slight stab when the time comes to separate from the companion of a day or a night." These are modern-day icons of elegance, tastemakers who are meant to inherit the lofty place vacated long ago by Hollywood stars.

Of course, men such as these, though few in number—I would hope to be counted among them—have always existed, and I consider myself fortunate to know some of these gentlemen personally. Some are old acquaintances, I met others while preparing this book. I have collected their confidences and examined their experiences as the first step in an effort to rewrite the rules of the art of fashion at the threshold of a new millennium. To uncover perfection in the art and technique of wearing a boutonniere, however, it is first necessary to understand the underpinnings of certain basic elements in men's fashion.

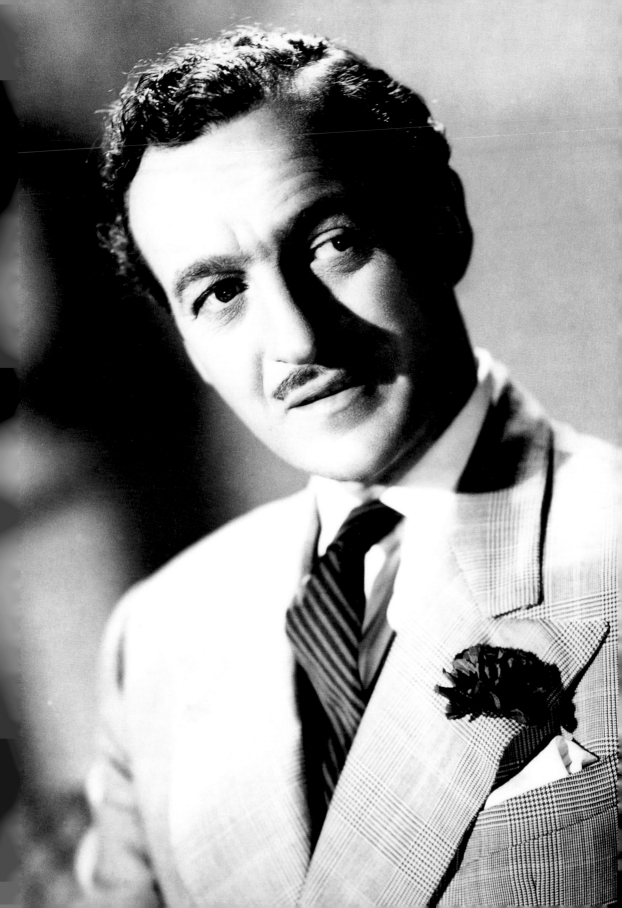

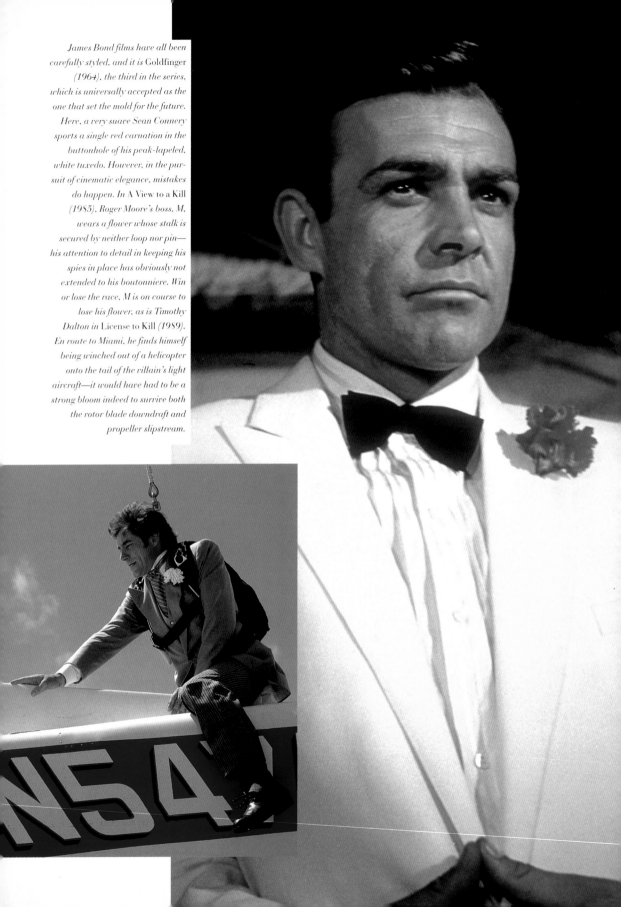

James Bond films have all been carefully styled, and it is Goldfinger *(1964)*, the third in the series, which is universally accepted as the one that set the mold for the future. Here, a very suave Sean Connery sports a single red carnation in the buttonhole of his peak-lapeled, white tuxedo. However, in the pursuit of cinematic elegance, mistakes do happen. In A View to a Kill *(1985)*, Roger Moore's boss, M, wears a flower whose stalk is secured by neither loop nor pin— his attention to detail in keeping his spies in place has obviously not extended to his boutonniere. Win or lose the race, M is on course to lose his flower, as is Timothy Dalton in License to Kill *(1989)*. En route to Miami, he finds himself being winched out of a helicopter onto the tail of the villain's light aircraft—it would have had to be a strong bloom indeed to survive both the rotor blade downdraft and propeller slipstream.

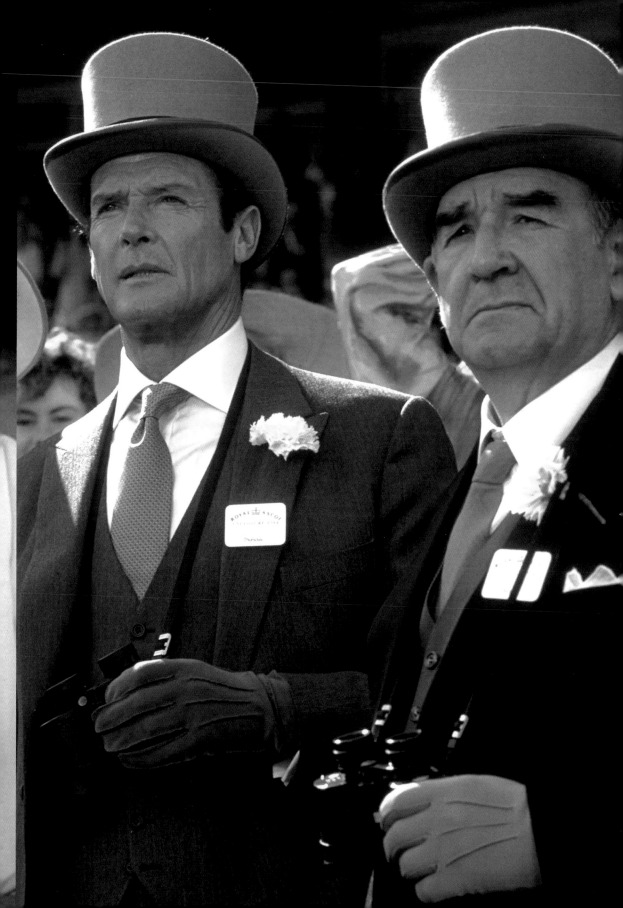

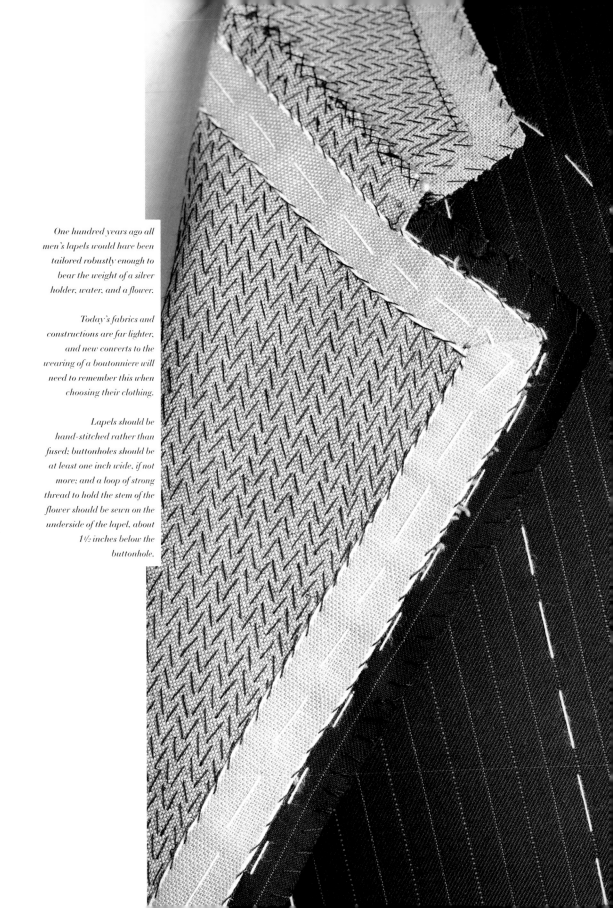

One hundred years ago all
men's lapels would have been
tailored robustly enough to
bear the weight of a silver
holder, water, and a flower.

Today's fabrics and
constructions are far lighter,
and new converts to the
wearing of a boutonniere will
need to remember this when
choosing their clothing.

Lapels should be
hand-stitched rather than
fused; buttonholes should be
at least one inch wide, if not
more; and a loop of strong
thread to hold the stem of the
flower should be sewn on the
underside of the lapel, about
1½ inches below the
buttonhole.

# THE JACKET

Normally, when a tailor put the final touches on a bespoke suit or sports jacket, it was standard procedure to finish the garment with certain optional details— among them were features that allowed for the proper wearing of a lapel flower. Sadly, this tailoring detail is rarely put into practice today, since many modern tailors know little of what is required to properly display a boutonniere and since few lapels today are constructed with enough rigidity to accommodate an elaborate or precious flower-holder. To make matters worse, many of today's ready-to-wear suits and jackets do not even feature a buttonhole in the lapel.

Trends to the contrary notwithstanding, a buttonhole in at least one lapel is, in fact, the first indispensable feature of a well-made suit—the jacket's true calling card. And while its original purpose was to fasten the top button to protect the neck from wind and cold—a function long since abandoned—its more noble purpose was to receive a boutonniere. Now that wearing a lapel flower is no longer fashionable, however, the buttonhole seems to have become little more than the favored location for the banal company badges worn by flocks of office workers and trade-show attendees.

When properly tailored, the buttonhole is hand-sewn, preferably with lustrous silk thread, which is stitched completely around the seam for strength. What is not so obvious is that the seamstress will first have laid some strong, corded thread along the cut edges of the cloth before oversewing the buttonhole. All this painstaking finishing work not only makes the buttonhole appear decorative and appealing but also contributes to its strength and durability, enabling it to resist wear and tear.

The lapel buttonhole should be larger than the conventional buttonholes below it, since sometimes a flower stem, or corolla, can be thick. Indeed, many believe that the hole must be large enough to house even a flower-holder, which is usually much wider than the stem, since it is meant to hold a small amount of water to keep the flower fresh.

Buttonhole size, however, is open to debate. The venerable Savile Row tailors Anderson & Sheppard, for example, recommend to their clients hand-sewn

In the final analysis, the flower-holder remains the true discriminating factor between those who would make an art of wearing a boutonniere and those for whom it is merely an occasional fancy.

buttonholes measuring 1⅛ inches. Luxury fabric manufacturer Sergio Loro Piana, on the other hand, abides by his own "rule of thumb," in a manner of speaking. Loro Piana maintains that his thumb must be able to pass easily through the hole.

Others are of the opinion that the size should be based more on the look of the overall garment than on mere functionalism. Clothing manufacturers who subscribe to this idea, however, invariably turn out suits with small lapel buttonholes that measure less than ⅜ inch long, barely enough space to hold a Rotary Club badge. I personally believe that a proper lapel buttonhole should measure at least 1 inch in length—sizeable enough to hold a mini– flower canister or a thick stem yet small enough to look discreet. Anything larger tends to be a detriment to the jacket's overall appearance if the buttonhole is not being used.

Also important is the method by which a boutonniere is fastened to the underside of the lapel. It is essential that the stem be held in place to prevent it from falling disastrously askew. The easiest method of anchoring the flower stem is by having the tailor stitch a strong cable of thread about an inch directly below the buttonhole. The loop should be loose enough to allow the stem to slip easily behind it but strong enough to hold it in place.

Finally, if one plans to use a minivase to keep the boutonniere in water, then it may be prudent to have the tailor fashion a pocket of sorts under the lapel, one with the appropriate depth, shape, and width. It is imperative that the lapel be strong enough to support such an apparatus, which can be somewhat heavy, particularly when filled with water. Any lapel constructed to the standards of bespoke tailoring will most likely be strong enough to support virtually any type of flower vial. But it should be noted that, by and large, the trend in tailored clothing over the last two decades toward lighter fabrics and "deconstructed" lightweight garments—designed under the false pretext of making the clothes more comfortable—does not ordinarily facilitate the use of flower-holders of any sort.

Essentially, a fine tailor-made jacket should be constructed with high-quality horsehair stiffening sewn in with several thousand hand-needled stitches. With regard to appearance, any lapel ambitious enough to host a flower should be of ample proportions; should match at least its width, with some cloth showing on either side; and should certainly not be the narrow, lanced lapel style popular back in the 1950s. Visually, a notched lapel can hold a smaller, somewhat symmetrical flower, while a peaked lapel may better accommodate a boutonniere of more unusual size or breadth. With the shawl-collar style, which is tailored without a buttonhole altogether, a flower is usually inappropriate, even with formalwear.

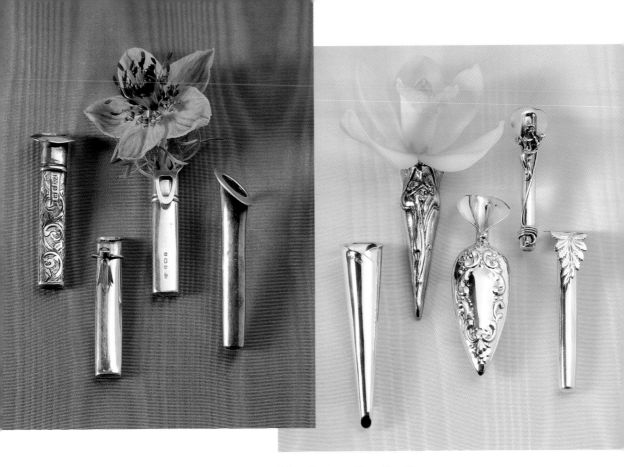

# THE  FLOWER - HOLDER

Few items in men's accessories today create a highly individualized sense of style. During more elegant eras, a highly prized item was the flower-holder—a tiny, oblong ersatz vase used to hold water for a boutonniere. The fine ones were made of silver, silver plate, or pewter and were sometimes adorned with a semiprecious stone. Often, these somewhat showy holders were worn in full view outside the lapel, pinned on as brooch, and, on rare occasions, pinned to a necktie. More often, however, they were discreetly placed behind the lapel, with just the top showing outside the buttonhole. Examples of these vintage holders can still sometimes be found in antique stores and certain flea markets, but they have little practical value, since they are invariably too large or too elaborate to be considered elegant today. There are even modern reproductions of these antiques, actually designed to function, but most are just gaudy, inelegant, and anachronistic.

*A selection of antique (left) and new (right) solid-silver flower-holders, some with elaborate art nouveau decoration, designed to contain just enough water to keep a boutonniere fresh all day.*

   The most classic, practical, and stylish model available now is the plain silver holder, which is valued as much for its fern-leaf design, meant to complement the flower's petals, as it is for its ability to stay in place in the button-hole. I suspect, though, that with the aid of a talented silversmith, more amusing and inventive versions could be possible; ones more suited to our times.

It is clear that in the tailored clothes of old, proper support was never a problem should a man wish to wear a boutonniere. Indeed, if a jacket was customized with the proper pouch, it could even adequately accommodate the disposable glass tubes today's florists sometimes employ for keeping single stems fresh.

It is perhaps worth mentioning that there was one other form of flower-holder in the days of yore. It consisted of a tiny bag made of waterproof silk. According to a floriculture manual dating back to 1876, "The flowers and fern are kept moist by a few sprigs of wet sphagnum moss, and the silk is bound round the whole close below the flowers. If a tube is not at hand, this is the next best substitute."

In the final analysis, the flower-holder remains the true discriminating factor between those who would make an art of wearing a boutonniere and those for whom it is merely an occasional fancy. One particularly innovative boutonniere enthusiast, German journalist Christian Vollbracht, employed tiny plastic bags or used ink cartridges as makeshift flower-holders until he was introduced to an antique flower-holder by an informed good Samaritan. Now Vollbracht confidently wears even the most delicate of blooms, including poppies and daisies. Indeed, the fact that it is possible to keep a lapel flower fresh, even for an entire day, underscores the wide range of possibilities that exist in deciding what variety of flower to wear. Some boutonniere wearers even report excellent results from using chemical nutrients to prolong a lapel flower's freshness.

One of my initial fears in wearing a flower-holder was that if I bent over, the water would run out, soaking my suit or even my shoes. But I happily discovered that spillage is highly unlikely due to a well-known law of physics. In fact, when I try to empty the flower-holder, I often need to turn it upside down and shake it violently.

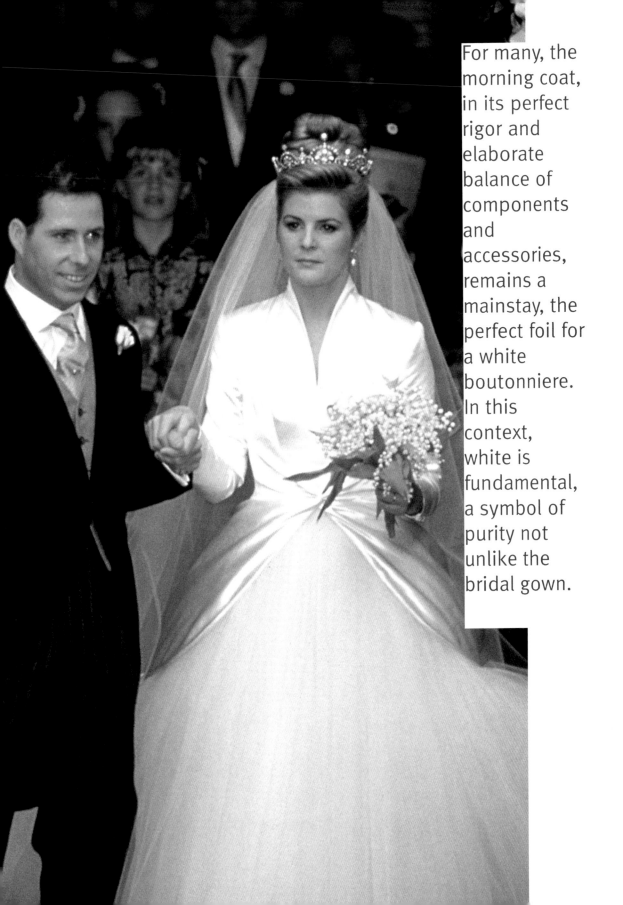

For many, the morning coat, in its perfect rigor and elaborate balance of components and accessories, remains a mainstay, the perfect foil for a white boutonniere. In this context, white is fundamental, a symbol of purity not unlike the bridal gown.

As we have already seen, the tradition of wearing a boutonniere is truly fascinating; it encompasses an eclectic variety of approaches and methods and counts among its practitioners some of the most dapper, if idiosyncratic, gentlemen of the century.

# T H E   F L O W E R

Odd as it may seem, despite the proliferation in recent years of vademecums and "style manuals" of male elegance, wherein every detail, basic step, and "classic" combination is set out in a series of pedantic rules based either on so-called tradition or on the personal views of a particular expert, virtually nothing exists in this type of literature on the boutonniere. In the few apropos lines I did manage to stumble upon, the author simply debated wearing a gardenia on a tuxedo and then wildly celebrated the return of classic elegance and debated the issues of leadership among various schools or philosophies of tailoring. Granted, some fashion magazines will on occasion run a piece featuring a boutonniere or two, but invariably the type of flower they choose is so showy and the context so improbable that the results, whether deliberate or not, are little more than a caricature of the form—hardly an encouraging message to young aspiring "dandies."

In what is perhaps an ironic twist, general ignorance on the part of the fashion media with regards to boutonnieres seems to have a beneficial result: if elegantly presented and carried out in step with the times, the "archaic" practice of wearing a boutonniere becomes, in the eyes of most people, extraordinarily innovative. Moreover, the future lapel-flower devotee might just begin to act upon the dictates of his own taste, without fear of being caged in by petty rules—the worst enemies of fashion creativity.

And so, surely to the immense disappointment of the self-proclaimed authorities on gentlemanly elegance, I begin this final yet essential segment of our topic—that of choosing a flower—by stating that the only rule is that there are no rules.

Ultimately, the sole beneficiary and final judge in the business of choosing a boutonniere flower is none other than the boutonniere wearer himself. As in all fields, the best way to insure freedom of choice is by fully understanding both the traditions that came before and all the viable options presently at hand. As we have already seen, the tradition of wearing a boutonniere is truly fascinating; it encompasses an eclectic variety of approaches and methods and counts among its practitioners some of the most dapper, if idiosyncratic, gentlemen of the century.

While there are no strict guidelines in choosing a flower, I believe that it is easiest to arrive at a consensus by starting with the modern male wardrobe in its most evolved, crystallized form—formal attire. Men's formalwear—both semiformal tuxedos and formal tailcoats—represent the final, perfected stage of this sartorial evolution. The traditional color scheme of formal clothing, of course, is contrasting black and white, and because there is no such thing as a naturally occurring black flower, it can reasonably be recommended that the lapel flower always be white,

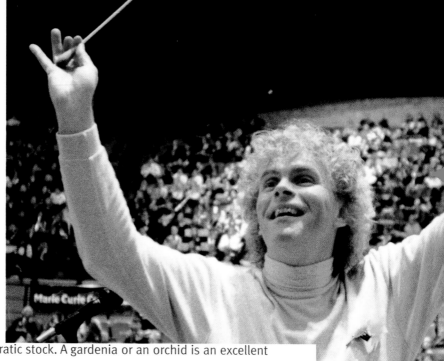

and preferably of aristocratic stock. A gardenia or an orchid is an excellent choice—classics, certainly, in and of themselves. If one prefers, a rose is also appropriate. In the summer, when the dinner jackets may be of a lighter hue, then the most appropriate color is still a variation of white, although the contrast of a red rose also works well.

Perhaps the last bastion of codified formal elegance still in practice today is the occasion of a formal wedding. For many, the morning coat, in its perfect rigor and elaborate balance of components and accessories, remains a mainstay, the perfect foil for a white boutonniere. In this context, white is fundamental, a symbol of purity not unlike the bridal gown. Indeed, a vintage book on the art of flower arranging has this to say: "At a wedding, the flowers worn by the groom should be like one in the bride's bouquet: a small orchid or lily of the valley. The bride's father and the best man wear the same species as the groom, or any distinctive white flower. The boutonnieres of the ushers are usually carnations, sweet peas, or small white roses."

I subscribe to the idea that the best man's lapel flower should correspond with that of the maid-of-honor, while the ushers' flowers should coordinate with those of the bridesmaids. The choice of flowers for a bride's personal bouquet, however, should be much more diverse and even exotic. While one should never stray too far from the classic blooms, the bride's bouquet, if one subscribes to the tradition that it should always contain only all-white flowers, could include the camellia, the dwarf chrysanthemum, the ranunculus, and the hyacinth. Should a scented note be desired, the bride should consider gardenias, tuberoses, stephanotis, or even a heady sprig of jasmine. As civil ceremonies become increasingly popular, however, and wedding dress norms become more and more eclectic, color schemes today may well be considered open to choice.

*Even though the lapel-less world of modern men's casualwear threatens to rob boutonnieres of a place to rest their stems, a good idea cannot be kept down for long. Sir Simon Rattle, the new principal conductor of the Berlin Philharmonic Orchestra, takes time to add that extra florish a flower gives to even an informal performance.*

Selecting the appropriate flower to wear in a lapel at a wedding can also be dictated by the time of year and the locale of the ceremony itself. Traditionally, orange blossoms are symbolic of winter, for example. A 1959 magazine noted another tradition: "White heather is often used for the buttonholes at Scottish weddings when the men are resplendent in kilts." In the Far East, minibouquets are specially made for a man's lapel. They include rosettes, silver paper, and often excessive foliage pinned to the outside of the bouquet. The composition of the arrangement is reflective of each guest's family rank; the more elaborate the arrangement, the more important the person. At one wedding I attended in Hong Kong, I politely tried to refuse such a bouquet in favor of a simple orchid but soon realized that to insist further would be to go against protocol and would be considered an insult.

In the end, boutonnieres for these types of occasions, despite some variety in color and choreography, provide the wearer with little sense of individuality or originality, since they are the same for everyone. They are more evocative, in fact, of older traditions involving the wearing of buttonhole flowers—most notably those that survive, especially in the United Kingdom, in the form of religious commemorations and ceremonies honoring patron saints. To wit: narcissus for Wales's St. David, clover for Ireland's St. Patrick, a rose for England's St. George. A similar circumstance is Britain's Remembrance Sunday, which mandates the wearing of poppies, often (regrettably) artificial. And let us not forget the pomp and circumstance of Ascot, that equestrian festival of collective elegance, where morning coats adorned with richly colored, showy flowers are an absolute essential of the summer season.

In the realm of everyday use, common sense and good taste best dictate what to wear with what. Yet a German treatise dating back to 1920 informed gentlemen that two prior conditions must be met to justify the wearing of a boutonniere: the sun must be shining and the flower must harmonize with the suit. I disagree with the first conclusion, since it excludes the use of a flower in the evening hours.

It is indeed prudent, however, to consider the color of a suit or sports jacket in choosing an appropriate flower. Take a gray suit, for example. While a flower of any contrasting color is possible, it would be wise to match the flower with some chromatic element in the shirt or necktie. Legend has it that nineteenth-century dandies often decided what outfit to wear based entirely upon which cufflinks they favored most at the time. At the risk of going to similar extremes, one might consider the availability of a particular attractive flower when choosing the day's suit or sports jacket. But if one fails to find the perfectly colored flower to match, say, a tweed sports jacket, one option—rather than paint the petals, as legendary dandy Oscar Wilde is said to have done—is to place the stem of a daisy in colored water. After a short time, the bloom will take on the

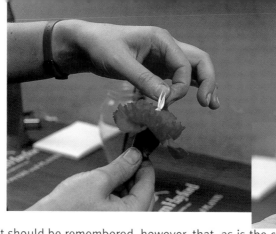

color of the water. It should be remembered, however, that, as is the case with dress shirts, white is always elegant and appropriate.

Which brings us to yet another debate. Certain pundits believe that a boutonniere worn in conjunction with a pocket square is too much of a good thing. Perhaps. But the presence of a demure flower will not necessarily render the pocket handkerchief superfluous. It will, however, undoubtedly require sobriety in the mixing of patterns and discretion in the way it is tucked into the breast pocket. A flower with a strong presence in terms of color or shape may well reduce the visual role of a pocket square to a simple horizontal line, rather than having the tips point up or puff out.

A man would be well advised to wear the most common or colorful flowers with his most "sporty" jackets or suits, saving the more precious, demure boutonnieres for his darker, more elegant suits. Obviously, those men engaged in the arts or any other creative profession are allowed greater freedom here than those in law or accounting. And those who work outdoors should be afforded a more liberal choice than that which might be appropriate at a board meeting. That said, however, there is value in exclusively opting for a single, distinctive flower in one consistent color. In this way, a man's choice of lapel flower becomes a recognizable part of his personal style, a signature of sorts.

Among the most versatile and readily available flowers that make good boutonnieres are carnations and cornflowers, both of which are often seen in myriad colors and are the only blooms capable of lasting an entire day without water. They are also strong enough to stand up to the weight of an overcoat, although it is a good idea to transfer the flower from the jacket lapel to that of the topcoat and vice versa. The Duke of Windsor always made sure his overcoats were finished with a working buttonhole in the lapel, along with a cable on the lapel's underside to anchor a boutonniere securely.

Another controversy surrounding the boutonniere concerns the appropriateness of showing a flower's leaves as well as its petals. I am of the opinion that the boutonniere works best in its most essential form, as a purely decorative and balanced part of the whole. Excessive realism, including leaves as well as blooms, can be too distracting unless a strong ecological message is desired—then, the

*While a boutonniere may look entirely natural, it may have undergone a hidden reconstruction process to enhance both its appearance and longevity. Here, skilled hands at William Hayford's florist shop, in the City of London, make about twenty traditional boutonnieres every morning for regular clients.*

presence of sprigs or leaves is justified. The same goes for very small flowers such as lilies of the valley or heather, which are usually worn as sprays.

Ultimately, a man would do well to enlist the expertise of a competent florist at some point, perhaps in order to learn firsthand the professional method of preparing a buttonhole, which, if executed well, is nothing less than a work of art and can improve upon nature. In my experience, watching a florist's dextrous fingers select and delicately prepare a bloom is truly mesmerising. First, most of the stalk and all the excess greenery or petals are carefully removed, after which a thin wire is inserted into the base of the bloom. This step, in turn, is followed by the insertion of a second, finer wire into the calyx. A small number of leaves are then threaded onto this wire; for a single rose, three leaves are generally sufficient. The finished boutonniere is then gently placed in the buttonhole of the lapel to be adjusted by the wearer. It seems woefully unfair that while the skill a tailor puts into the intricate stitchwork of a hand-sewn buttonhole may be admired for years, even decades, evidence of the florist's craftsmanship lasts but a day.

When traveling in foreign countries, it may be appropriate to wear indigenous flowers or the national bloom as a way of flattering a host. Since few people ever take the time to learn a country's national floral symbol, wearing one out of respect can be a source of amusement and surprise. A word of caution here: proper research may be prudent, since certain flowers retain negative connotations in the local folklore in some countries. In Italy, for example, the chrysanthemum is always associated with bad luck, since it is normally used exclusively for funeral decorations.

I have appended a list of countries with their corresponding national flower, although not every nation lays claim to one, odd as that may seem. Almost every country, however, has a favorite, for either historical, economic, or folkloric reasons. In Denmark, for example, it is the daisy, or marguerite, because this is their queen's name. Japan's official flower is that of the imperial family, the chrysanthemum, but the best-loved, most popular flower is the cherry blossom.

In some cases, knowing the official flower will be of no help at all—try wearing a thistle in Scotland—but it is never a pointless exercise to learn all one can about a particular country's history and social customs. A case in point is

61

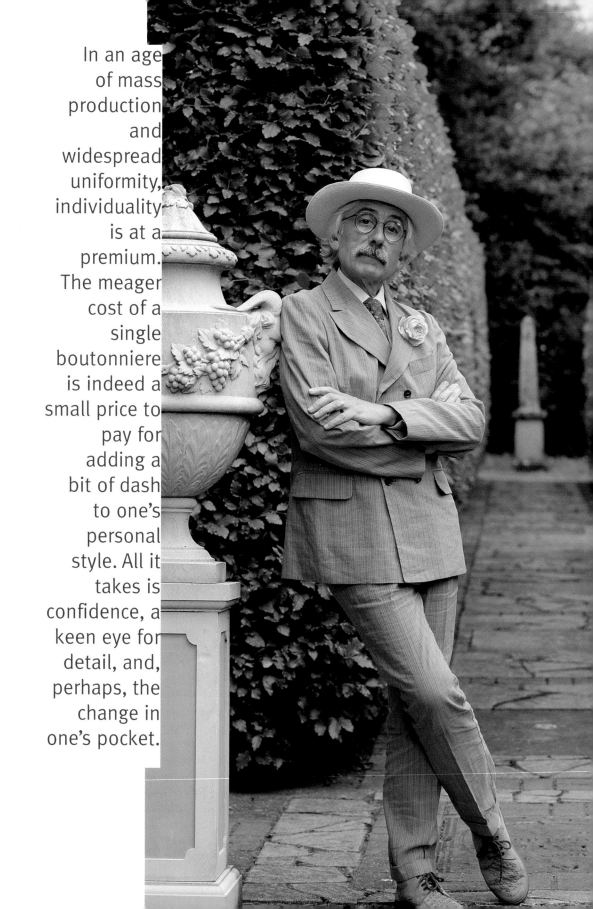

In an age of mass production and widespread uniformity, individuality is at a premium. The meager cost of a single boutonniere is indeed a small price to pay for adding a bit of dash to one's personal style. All it takes is confidence, a keen eye for detail, and, perhaps, the change in one's pocket.

Portugal, where the return of democracy is known as the Carnation Revolution. Another country with a historically significant flower is England, where the War of the Roses pitted the white Lancashire rose against the red Yorkshire rose. As a result of the peace made between the two warring houses, the Tudor rose was created—a hybrid of both roses, with both colors, that today is still a floral symbol of the United Kingdom.

Yet another cultural tradition can be brought to life through the boutonniere's return: the so-called "language of flowers." This visual code enjoyed its heyday in Victorian England, where several hundred plants, including leaves, shrubs, and flowers, were accorded specific meanings. Unfortunately, little of this startlingly large vocabulary survives in common usage today, save for in such stalwart institutions as St. Andrews University in Scotland, where it is still appropriate to exchange buttonholes and corsages during student balls. Sadly, the source of meaning attached to this exchange has been reduced merely to the use of one color rather than another, with little or no importance placed on the species.

Two strands of modern life may well support a revival of the fashion for wearing boutonnieres. First, there is a huge upsurge of interest in gardening and growing flowers in urban as well as country locations. Second, our homes are becoming increasingly filled with flowers and and floral-scented candles all year round as well as with aromatherapy oils in the bathroom—all, no doubt, symptoms of our wish to remind ourselves of the benefits that nature brings to our ever-more-hurried urban existence.

All said, it should not be all that difficult to revitalize the romantic tradition of donning a flower in one's lapel without seeming to succumb to the arcane rituals of the past. Yet there is one major caveat that bears mentioning: artificial flowers, no matter how realistic, should never be worn in place of a living bloom, not even for the most noble of reasons. Although there is a reason to use artificial flowers for fund-raising, no one can deny that they surely strike a fatal blow to elegance.

In an age of mass production and widespread uniformity, individuality is at a premium. The meager cost of a single boutonniere is indeed a small price to pay for adding a bit of dash to personal style. All it takes is confidence, a keen eye for detail, and, perhaps, the change in one's pocket.

*opposite: Sir Roy Strong, formerly the director of Britain's National Portrait Gallery and the Victoria & Albert Museum, is now a prominent broadcaster, columnist, and author, whose books on art, history, and gardening have given him a unique insight into the relationship between flowers and men's historic costume. Sir Roy is in the formal garden he created with his wife, Julia Trevelyan Oman, another eminent historian, at their country home.*

*above: As an international statesman of unquestioned stature, former president of South Africa Nelson Mandela has always understood the importance of being well dressed as a sign of good manners, respect for other people, and a sense of occasion.*

# The
# Well-Dressed
# Lapel:

Most people, particularly those who wear very casual clothes every day of their lives, like to dress up and look their best from time to time. If you have dipped into the earlier pages of this book, you realize that there is a long and intriguing history to men wearing flowers, whether in the design of their clothing or real ones in the lapels of their jackets.

Brioni, with the assistance of New York floral designer Amy Jacobus, has created this modern guide to what flowers go best with what clothes and for what occasions. They include boutonnieres that every Edwardian boulevardier would recognize, but they have also created some new, very contemporary styles, which might lead to the renaissance of the boutonniere—a custom much needed in this all too mass-produced age.

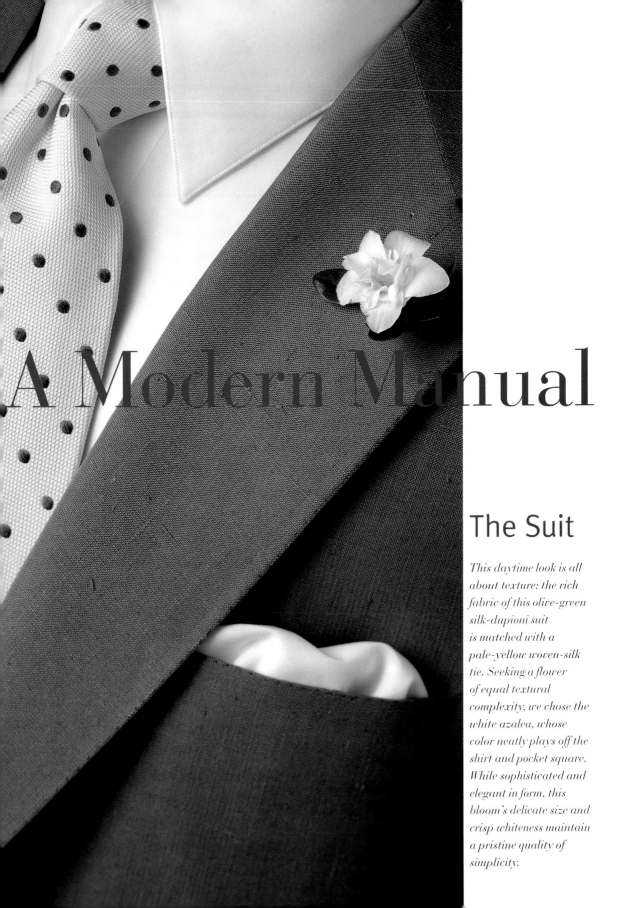

# A Modern Manual

## The Suit

*This daytime look is all about texture: the rich fabric of this olive-green silk-dupioni suit is matched with a pale-yellow woven-silk tie. Seeking a flower of equal textural complexity, we chose the white azalea, whose color neatly plays off the shirt and pocket square. While sophisticated and elegant in form, this bloom's delicate size and crisp whiteness maintain a pristine quality of simplicity.*

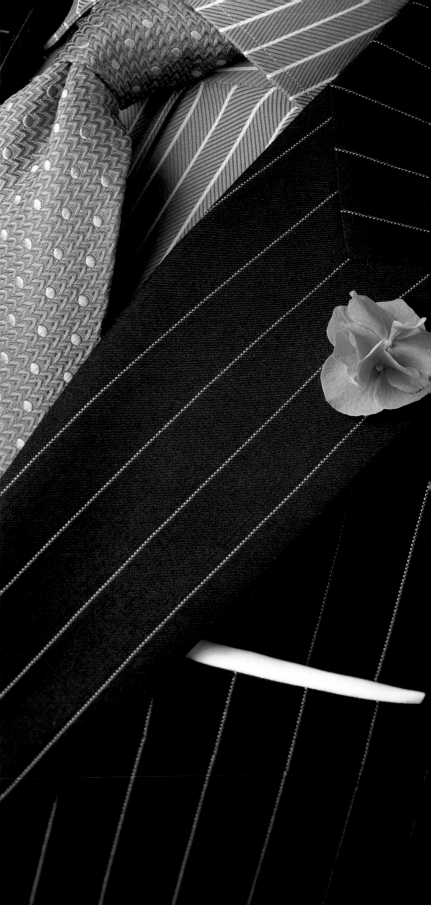

*right:* This bold striped suit tells a story of complementary patterns and tones. Several shades of blue are visible here: in the narrow stripe in the suit, the wider stripe in the shirt, and the dots in the tie. Rather than trying to match one of these blues, this bluebonnet hydrangea enhances those surrounding it. If you are familiar with the hydrangea, you will note that this boutonniere is significantly smaller than the actual flower. Here our florist constructed a small but elegant boutonniere from selected petals of the larger bloom—a simple solution to keep in mind if your flower of choice is too large for the lapel.

*opposite:* It`s important to realize that one can dress down a suit and remain casually elegant. Paired with an ascot and a button-down shirt, this suit is transformed into something more modern. The hypericum featured in this boutonniere is equally modern and more casual than a flower. In addition, it works particularly well for its autumnal quality; the warmth of its browns and richness of its green leaves reflect the olive-and-brown tweed of the suit.

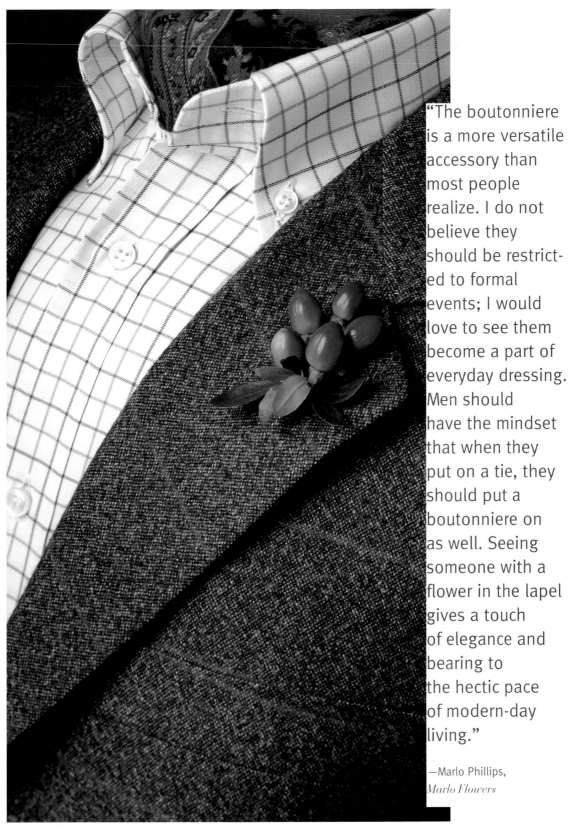

"The boutonniere is a more versatile accessory than most people realize. I do not believe they should be restricted to formal events; I would love to see them become a part of everyday dressing. Men should have the mindset that when they put on a tie, they should put a boutonniere on as well. Seeing someone with a flower in the lapel gives a touch of elegance and bearing to the hectic pace of modern-day living."

—Marlo Phillips,
*Marlo Flowers*

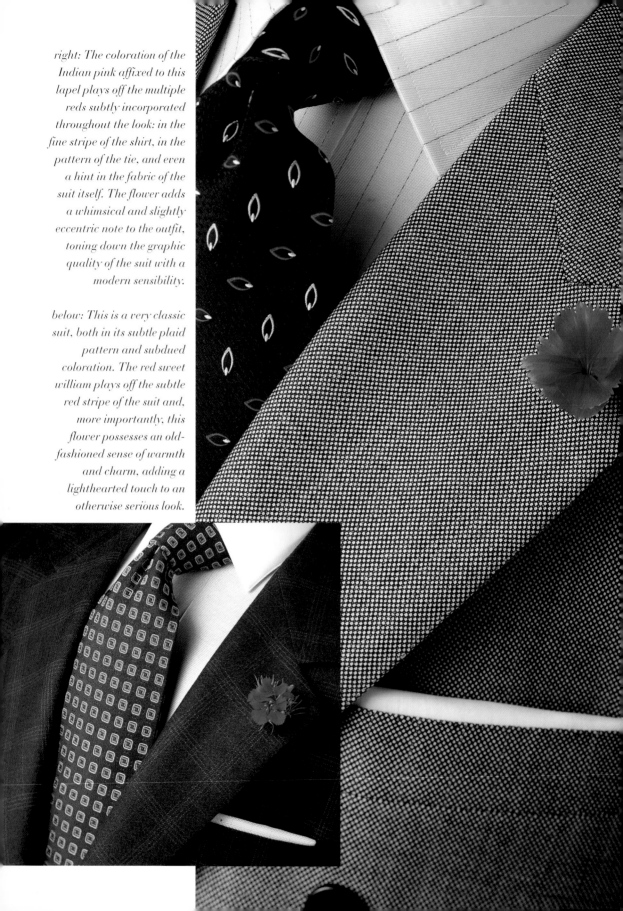

*right:* The coloration of the Indian pink affixed to this lapel plays off the multiple reds subtly incorporated throughout the look: in the fine stripe of the shirt, in the pattern of the tie, and even a hint in the fabric of the suit itself. The flower adds a whimsical and slightly eccentric note to the outfit, toning down the graphic quality of the suit with a modern sensibility.

*below:* This is a very classic suit, both in its subtle plaid pattern and subdued coloration. The red sweet william plays off the subtle red stripe of the suit and, more importantly, this flower possesses an old-fashioned sense of warmth and charm, adding a lighthearted touch to an otherwise serious look.

# WILD FOR WILDFLOWERS

Christian Volbracht
*Journalist*

I have worn a flower in my lapel nearly every day for the last decade. In fact, the only time I don't wear one is when I'm not wearing a jacket—no buttonhole, no flower. I did not take to wearing a boutonniere to imitate anyone but rather out of playfulness and the joy of appreciating nature's beauty.

Since I live close to where I work, I often pick flowers for my lapel along the way. It still amazes me how many species there are growing right in the middle of town. Other sources include my own balcony—where I often keep flowers—and, naturally, the local florist.

Extravagance is probably my primary motivation for wearing a boutonniere, along with a bit of vanity and a desire to convey style and elegance by way of the smallest detail. Nearly everyone reacts to this tiny touch of color on the lapel (it may even distract one's attention from a dusty pair of shoes).

I work in a profession—journalism—that allows for a certain freedom in matters of style. Rarely is a necktie mandatory in my work, and I often wear light and colorful polo shirts to the office. Since I am in charge of a rather large news agency, however, I am often in a position where I need to make quick and precise decisions. In this relatively serious business, it is an advantage to be able to hint at a less serious, more human and creative side to one's personality. In truth, I have always met with positive, if silent, reactions whenever I wear a boutonniere. Businessmen obsessed only with business tend to ignore the flower, of course, but the reaction of most other men, and of a multitude of women, often ranges from polite interest to utter fascination. As for the flower itself, my first choice is generally a wildflower picked in its natural site. I never choose carnations and wear cultivated roses only rarely. I also like to wear elder and jasmine flowers, dandelions, or wild roses—and sometimes lion's tooth or the season's first lilies of the valley. For evening, the flowers can get a bit more extravagant: small parrot tulips or spectacular clematis, but never orchids.

Traveling can sometimes make it difficult to maintain the boutonniere habit. I must confess that at times I've even resorted to stealing a flower or two; I have been known to pinch a few blooms out of hotel lobby vases, private gardens, and public parks. I often take pleasure in revealing their provenance to my host.

Perhaps my fondness for a flower in the lapel is my subconscious way of looking for a bride. When my present companion and I first began dating, I would always wear a passion flower, giving little thought to the religious meaning of this unusual blossom, thinking instead only of the immediate meaning of "passion."

According to Oscar Wilde, "A really perfect buttonhole flower is the only thing to unite art with nature." Wearing a boutonniere brings a touch of nature to my life wherever I may be, and perhaps it helps me live my life in a way that approaches art. But the simplest explanation for my daily touch of extravagance is that this seemingly small gesture adds great joy and beauty to my world. What more justification can there be?

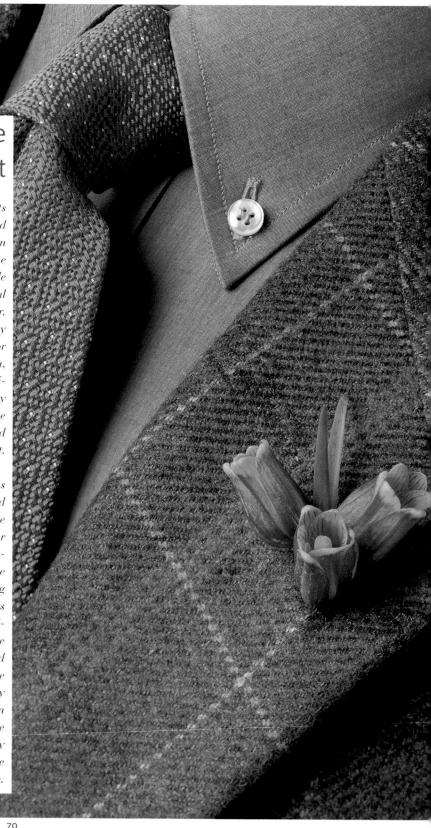

# The Sports Coat

*right: This cashmere sports coat is made more relaxed with a simple button-down shirt. In the same spirit, the boutonniere presents a triple bloom, inherently less formal than a single flower. Fritillaria, a floral variety more informal than, for example, a rose or gardenia, was chosen for its extraordinary coloration that perfectly coordinates with the autumnal brown-and-gold tones of the jacket.*

*opposite: Because this sports coat is a blend of linen and wool, it is meant for the spring, and the flower suggested here has a correspondingly breezy, springlike feeling. There is something carefree and spontaneous about the choice of delphinium, a flower that reflects the exuberance of spring and accordingly offsets the complexity of the many patterns and textures within this overall look. At the same time, its blue color perfectly complements the blues of the jacket, shirt, and tie.*

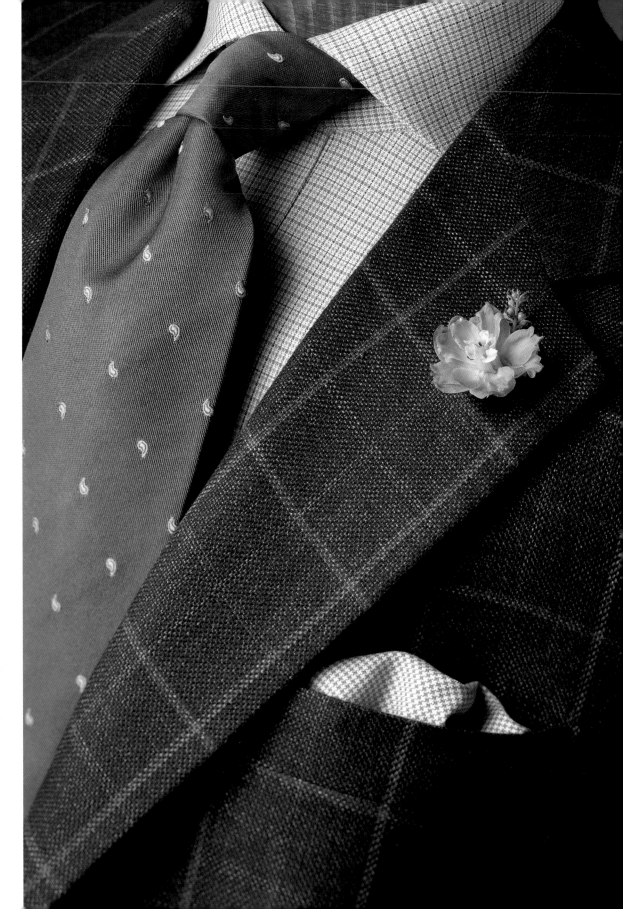

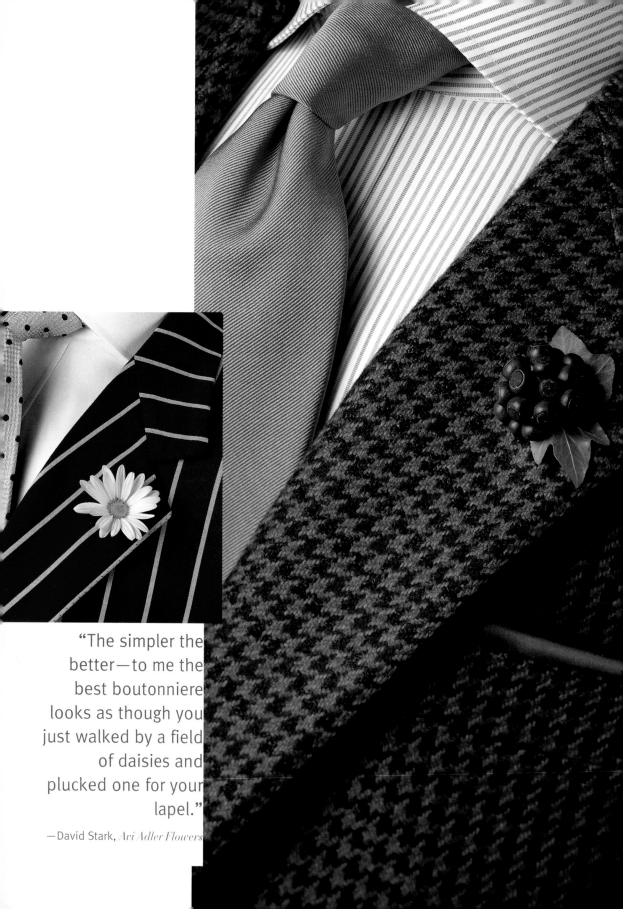

"The simpler the better—to me the best boutonniere looks as though you just walked by a field of daisies and plucked one for your lapel."

—David Stark, *Ari Adler Flowers*

# IN THE FAMILY TRADITION

Derrill Osborn
*Retailer*

My ancestry consists of pure English on one side and pure Cherokee Indian on the other. Both my grandfathers were pioneer settlers in New Mexico. When I was a child, on special occasions they both would wear seasonal prairie flowers in the buttonholes of their jackets. Each of them also had a buttonhole sewn into the lapel of their vests, so that they could transfer the flower whenever they took off their jackets. My grandmother had a signature boutonniere stitch in which she tacked strong red silk on each end of a thread cable on the back of the lapel for strength.

On many occasions I witnessed my grandfather crawl on top of a gigantic stud thoroughbred, pull his ten-gallon hat down tight, and gallop across the plains, his lapel flower intact. Indeed, the image of these burly men, with their massive hands, sweeping down into a pool of fragile prairie flowers, clipping one off with their razor sharp fingernails at just the right part of the stem to allow it to sit behind the boutonniere stitch with nary a bruised petal, has stuck with me all these years.

Prairie flowers grow in a resplendent array of brilliant shades, each of which blends with the terrain. The finishing touch of a simple flower set these men apart in a room full of toughs. There was a gentility about them. They possessed a certain cowboy grace. In simplest terms, these men taught me the virtues of wearing one of God's most beautiful creations—a flower—as a gesture of devotion. In turn, whenever I wear one I feel blessed.

I have donned a boutonniere all my adult life. My mother used to say that I was born with a flower in my lapel. I have also had to ignore the host of eyes upon me whenever I stroll down a busy avenue, hear the word "dandy," or witness a passing couple elbowing each other. Now it seems the entire world expects me to wear a flower, and, indeed, I feel naked wouthout one. Frankly, I don't give a damn what effect my wearing a flower has on anyone else. It is a personal thing that only a handful of gentlemen have been bred to appreciate. Interestingly, when one of those men and I do come across one another, however rarely, we exchange a nod, a small gesture that indicates shared knowledge.

Like brushing your teeth, wearing a boutonniere becomes a natural habit. Whenever I travel, I do my best to get my hands on a flower. If thievery is not appropriate, I will seek out a florist and purchase a variety for the duration of my stay, placing the flowers in a glass of water in the coolest part of my hotel suite. Each will then be ready to adorn my breast come morning. At judgment time, God will ask me why I thought it was OK to steal flowers. I am still thinking of my answer.

*opposite, left: The effusive nature of a dapper regatta-striped jacket worn with a pronounced polka-dot tie practically demands the pure, unselfconscious joy of a marguerite daisy. In form, the daisy is probably the most open of all flowers, and with an exuberant spot of yellow at its center, it offers a wonderful touch of color against the blues and whites of the jacket and tie.*

*opposite, right: Although the choice of an ivy berry is not as formal as that of a single bloom, this particular example has a formality to it because of its glossy patina and its deep, rich color playing off the subdued browns and grays of this luxurious, cashmere sports coat. A new twist on the use of the berry as boutonniere, this look is at once serious and elegant.*

# A FONDNESS FOR CARNATIONS

Felix Furlonger
*Real Estate, Chartered Surveyor*

In celebration of my return to civilian life following my service as a navigator in the Royal Air Force, I took to wearing a clove carnation in the left lapel buttonhole of my suit jackets. Though I was only in my early twenties at the time, I had the idea that a preoccupation with one's appearance was a natural instinct and provided the only visual indication of a man's self image. I often recalled Polonius's advice to his son Laertes: "Costly thy habit as thy purse can buy—not expressed in fancy, rich not gaudy, for the apparel oft proclaims the man." I also recalled the words of my father: "Never do any work which requires you to take off your coat; it will be underpaid and probably injurious to health."

I would be remiss if I failed to mention the seminal influence of the black-and-white films of the thirties in which Bryan Aherne, Clive Brook, Leslie Howard, George Sanders, and Cary Grant dashed around in convertible Lagondas or Bentleys accompanied by gorgeous women. These heroes were invariably attired in Savile Row suits of chalk-stripe flannel or Glenurquhart checks that were embellished, as often as not, with a carnation in the lapel buttonhole.

And so in 1946 I called on Henry Poole of Savile Row and had a one-and-a-half-inch buttonhole sewn into the lapel of a series of suits I had ordered, making sure that the tailor added a silk bar behind the lapel to accommodate the calyx of a clove carnation.

Still, even during that era, I do not think the practice of wearing a boutonniere was ever widely adopted, except on gala occasions such as race meetings at Epsom, Ascot, and Goodwood and at the Royal Regatta at Henley. Diehards I know still wear blue cornflowers to the cricket matches at Eaton and Harrow. Personally, I favor plain gray or blue suits with cream shirts, a cream or blue silk handkerchief tucked casually in the breast pocket, and a plain blue tie to complement the dark-red carnation in my buttonhole.

Today, after fifty years of wearing carnations, I am unaware of any public disapproval of the habit, and ladies often murmur their appreciation. In England, clove carnations are imported from the Channel Islands and are available from the top florists in the West End and Knightsbridge. Whenever I am abroad I usually carry a half dozen in a thermos container filled with ice. They survive for two or three weeks if the stems are clipped and they are kept in the hotel bathroom. I've never used one of those miniature water containers in my lapel since they tend to be cumbersome and obtrusive and smack of a preoccupation with horticulture.

I cannot honestly say that I see any virtue in affecting a boutonniere; it is merely a benign and frivolous habit, particularly if one likes carnations. But, unlike so many diversions today, wearing a flower in one's lapel is entirely free from any injury to health.

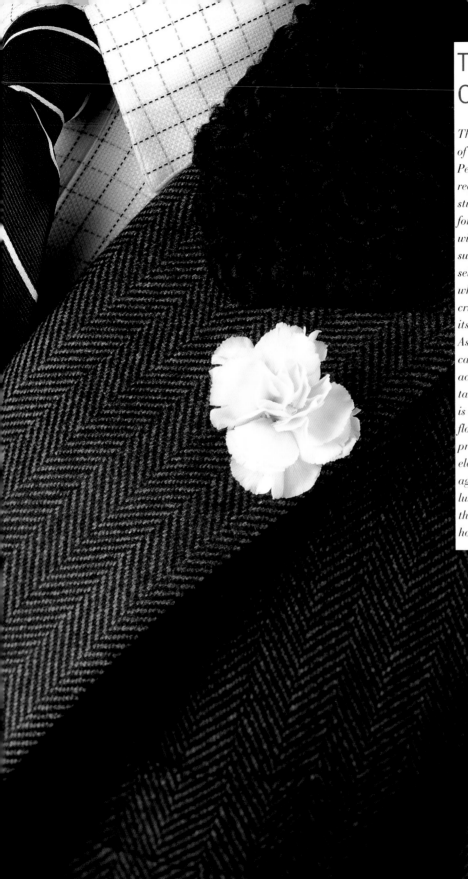

# The Overcoat

*The super-luxe nature of this cashmere and Persian-lamb coat requires a flower that is sturdy and beautifully formed; a fragile bloom will not stand up to such a garment. We selected a miniature white carnation for its crispness of color and its unpretentiousness. As a variety, the carnation is readily accessible and often taken for granted. It is time to resee this flower for its underappreciated natural elegance. Here, up against the most luxurious of garments, the carnation truly holds it own.*

# The Wedding

*Full morning dress, including a charcoal-gray morning coat, dove-gray vest, light-gray with black multistriped pant, wing-tip shirt, and silver-gray and black-striped ascot, accented here with an antique diamond stickpin, is the ultimate in classic wedding attire. The modern morning coat is evocative of another time— as is this flower. We love the tradition inherent in lily of the valley, a pure white bloom that connotes something very formal. This flower is often thematically part of the bride's bouquet and, like her bouquet, this spray of blooms, loosely arranged in a vintage-inspired vial affixed through the button- hole, will stay fresh all day.*

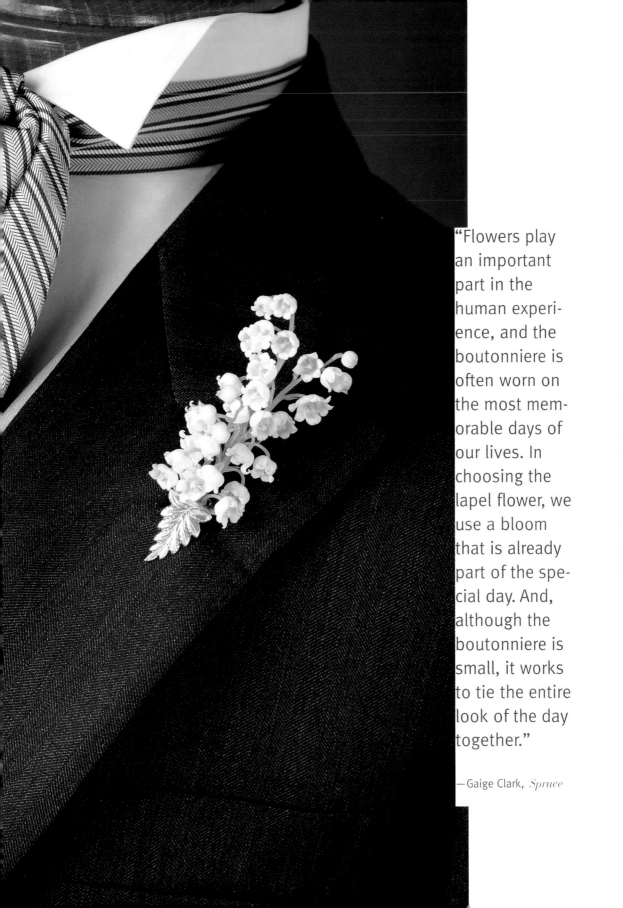

"Flowers play an important part in the human experience, and the boutonniere is often worn on the most memorable days of our lives. In choosing the lapel flower, we use a bloom that is already part of the special day. And, although the boutonniere is small, it works to tie the entire look of the day together."

—Gaige Clark, *Spruce*

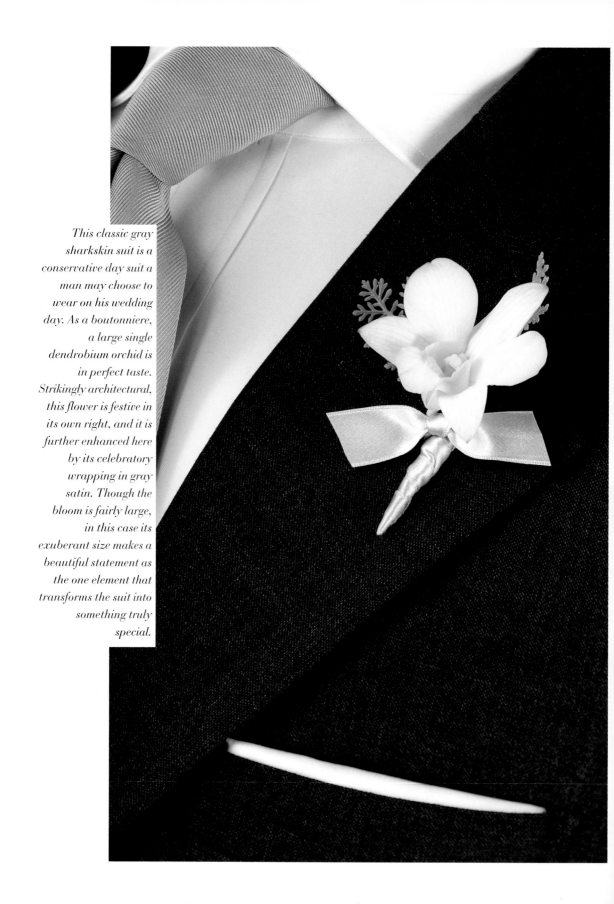

*This classic gray sharkskin suit is a conservative day suit a man may choose to wear on his wedding day. As a boutonniere, a large single dendrobium orchid is in perfect taste. Strikingly architectural, this flower is festive in its own right, and it is further enhanced here by its celebratory wrapping in gray satin. Though the bloom is fairly large, in this case its exuberant size makes a beautiful statement as the one element that transforms the suit into something truly special.*

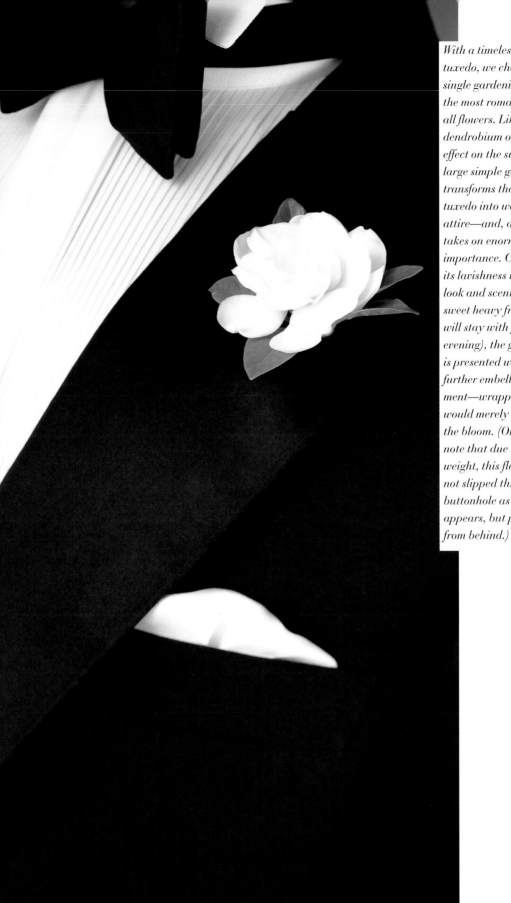

With a timeless black tuxedo, we chose a single gardenia, one of the most romantic of all flowers. Like the dendrobium orchid's effect on the suit, the large simple gardenia transforms the classic tuxedo into wedding attire—and, as such, takes on enormous importance. Chosen for its lavishness in both look and scent (the sweet heavy fragrance will stay with you all evening), the gardenia is presented without further embellish- ment—wrapping would merely diminish the bloom. (One should note that due to its weight, this flower is not slipped through the buttonhole as it appears, but pinned from behind.)

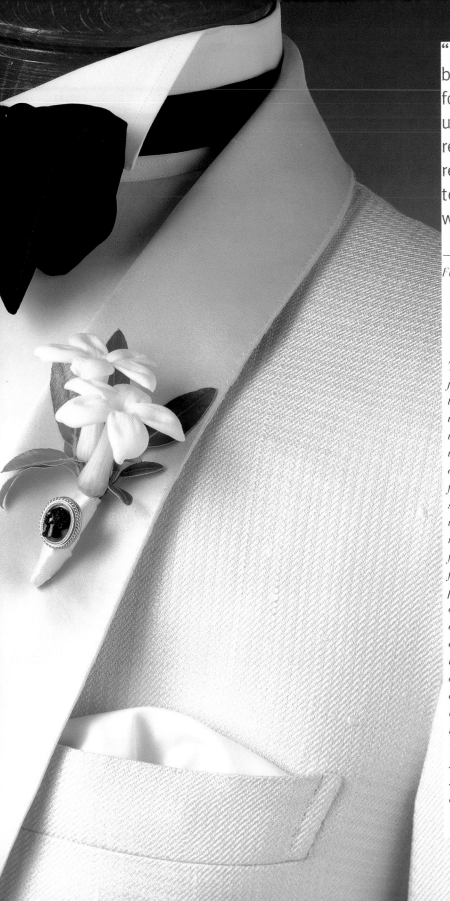

"The boutonniere for the modern urban man re-avows his relationship to the natural world."

—Ron Wendt, *Ron Wendt Floral and Event Design*

*This cream-colored dinner jacket is far less conservative than the preceding wedding looks—even without a boutonniere, the wearer is already making a statement. For the perfect floral accompaniment, stephanotis was chosen for its graphic, architectural nature; though not a large flower, the precision of its form looks important. We put two blooms together to create a vertical display and wrapped them in cream satin. As a finishing touch, a black cameo antique stickpin was added to punch up the black in the cummerbund, tie, and tuxedo pant. The overall effect is a very studied elegance—as sophisticated as the choice of the clothes themselves.*

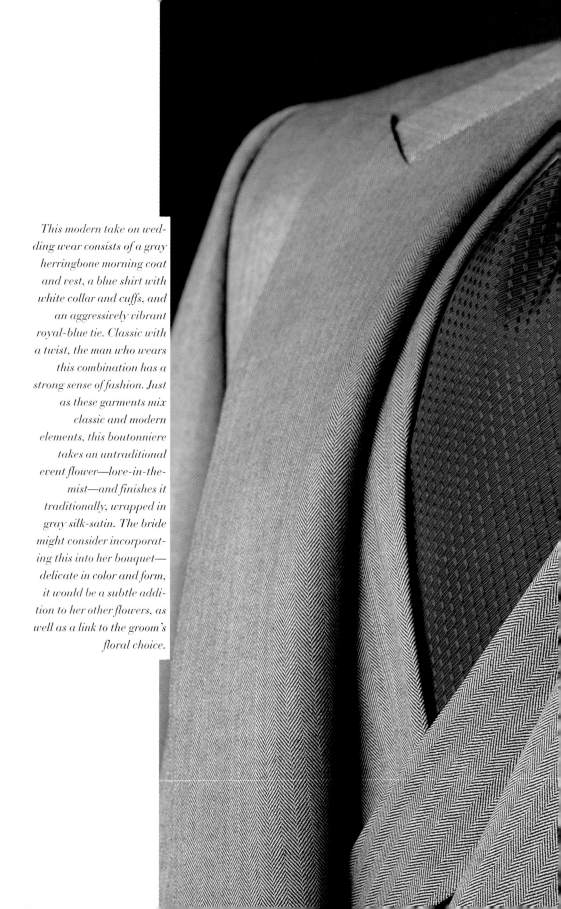

*This modern take on wedding wear consists of a gray herringbone morning coat and vest, a blue shirt with white collar and cuffs, and an aggressively vibrant royal-blue tie. Classic with a twist, the man who wears this combination has a strong sense of fashion. Just as these garments mix classic and modern elements, this boutonniere takes an untraditional event flower—love-in-the-mist—and finishes it traditionally, wrapped in gray silk-satin. The bride might consider incorporating this into her bouquet— delicate in color and form, it would be a subtle addition to her other flowers, as well as a link to the groom's floral choice.*

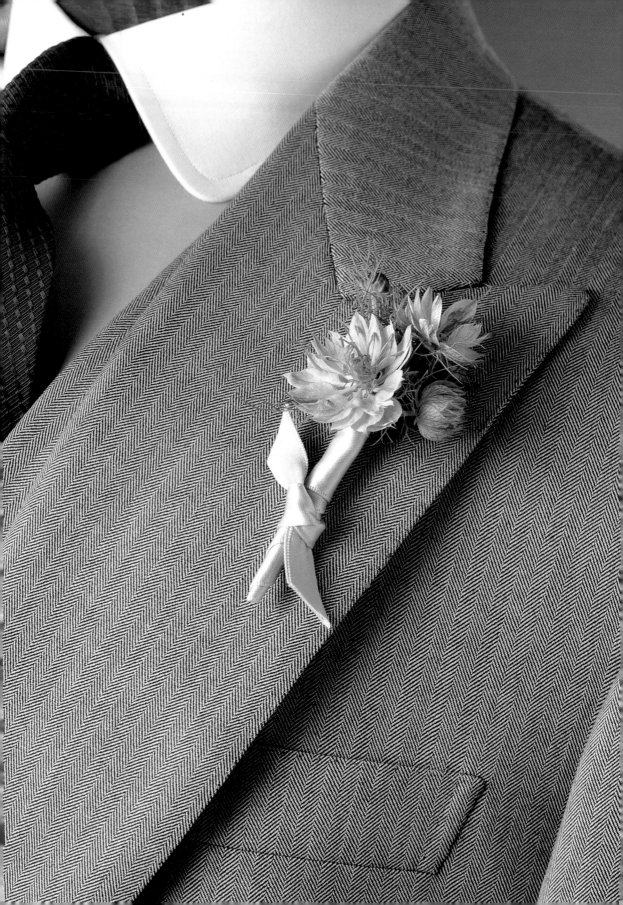

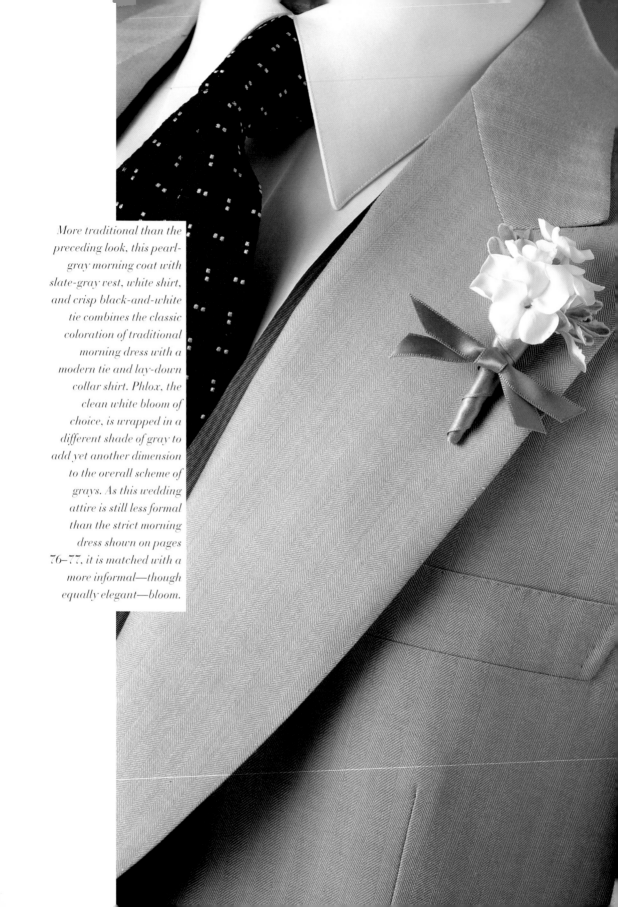

More traditional than the preceding look, this pearl-gray morning coat with slate-gray vest, white shirt, and crisp black-and-white tie combines the classic coloration of traditional morning dress with a modern tie and lay-down collar shirt. Phlox, the clean white bloom of choice, is wrapped in a different shade of gray to add yet another dimension to the overall scheme of grays. As this wedding attire is still less formal than the strict morning dress shown on pages 76–77, it is matched with a more informal—though equally elegant—bloom.

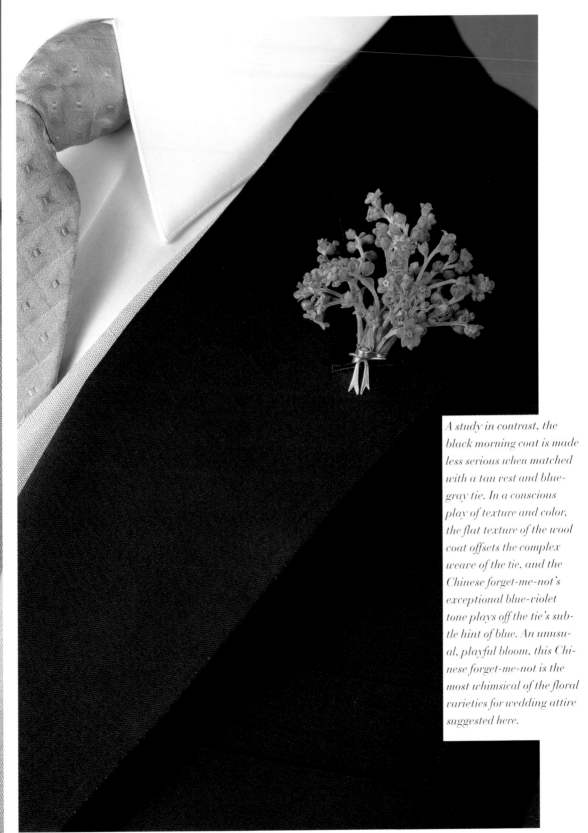

A study in contrast, the black morning coat is made less serious when matched with a tan vest and blue-gray tie. In a conscious play of texture and color, the flat texture of the wool coat offsets the complex weave of the tie, and the Chinese forget-me-not's exceptional blue-violet tone plays off the tie's subtle hint of blue. An unusual, playful bloom, this Chinese forget-me-not is the most whimsical of the floral varieties for wedding attire suggested here.

# Formal Wear

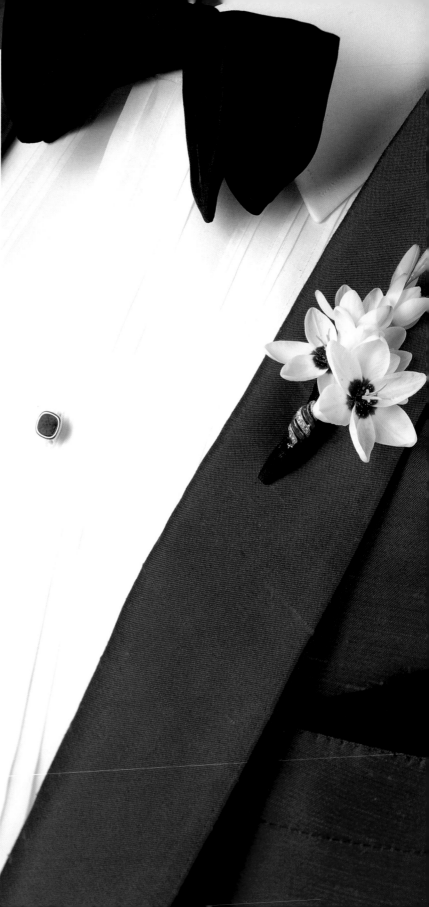

*right: With its narrow lapels, this red silk dinner jacket is very retro. For the boutonniere, we chose ixia, due to the extraordinary color of its red "throat." Normally this flower remains closed; we forced open the petals to show the flowers' dramatic red centers. To color coordinate further, we wrapped the blooms in black satin, matching the black piping on the jacket's lapels and sleeves, and added an art deco ruby-and-diamond stickpin. With its extravagant design and color, this look is not for the shy; it makes for an entrance of unmistakable elegance.*

*opposite: Another entrance-maker, this hunter-green tartan dinner jacket has an old aristocratic feel. The black lily was chosen for its rich coloration, playing off the deep jewel tones of the jacket, and it is wrapped in wine-colored silk to match the pocket square below. As a floral variety, the black lily is extremely magical, and when matched with this tartan jacket and antique crested stickpin, it is classically traditional in the best sense of the word.*

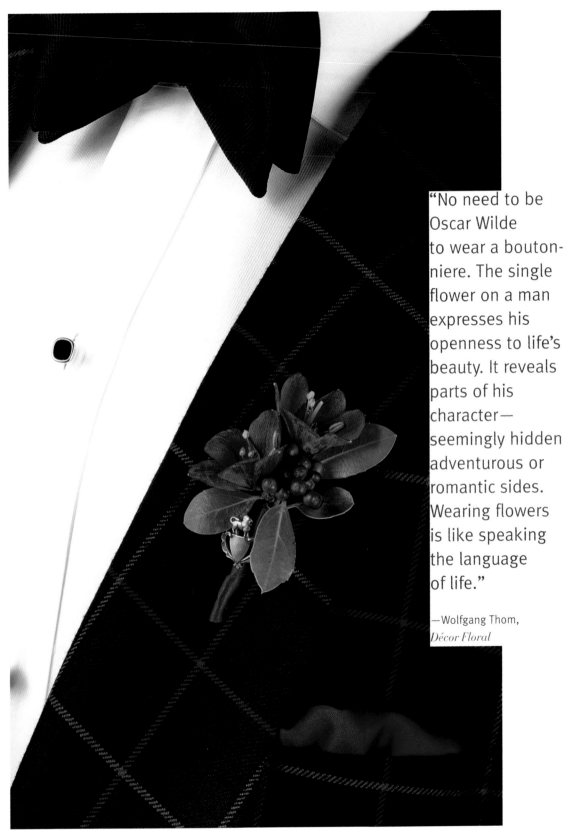

"No need to be Oscar Wilde to wear a boutonniere. The single flower on a man expresses his openness to life's beauty. It reveals parts of his character— seemingly hidden adventurous or romantic sides. Wearing flowers is like speaking the language of life."

—Wolfgang Thom, *Décor Floral*

*below: This novelty dinner jacket offers a playful alternative to the classic black tuxedo. Selected for its vibrant color, the yip sum wah orchid adds a striking touch of burning red to the crisp black and white of the jacket, shirt, and tie. Mirroring the double-note motif, we used two blooms rather than one, affixed through the buttonhole without further embellishment—given the jacket's pattern, the boutonniere should remain as simple as possible. As the orchid is a flower of great integrity, it can easily stand alone.*

*right: For the confident man who chooses to wear something truly remarkable, this ultra-luxurious silk-velvet smoking jacket finished with fancy silk braiding evokes the glamour of another time. To present the boutonniere we selected an art nouveau–inspired silver vial that pins directly onto the jacket. Grape hyacinth was chosen as much for its natural configuration as for its color—the three neatly upright blooms create a vertical display that shows off the vial in its entirety without any obstruction of petals or greens.*

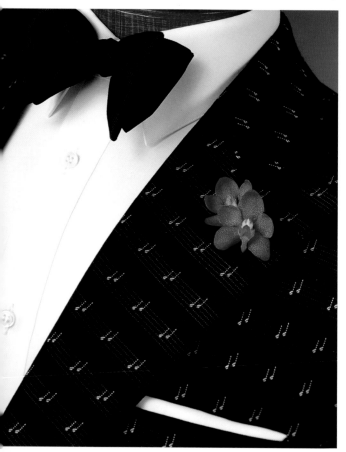

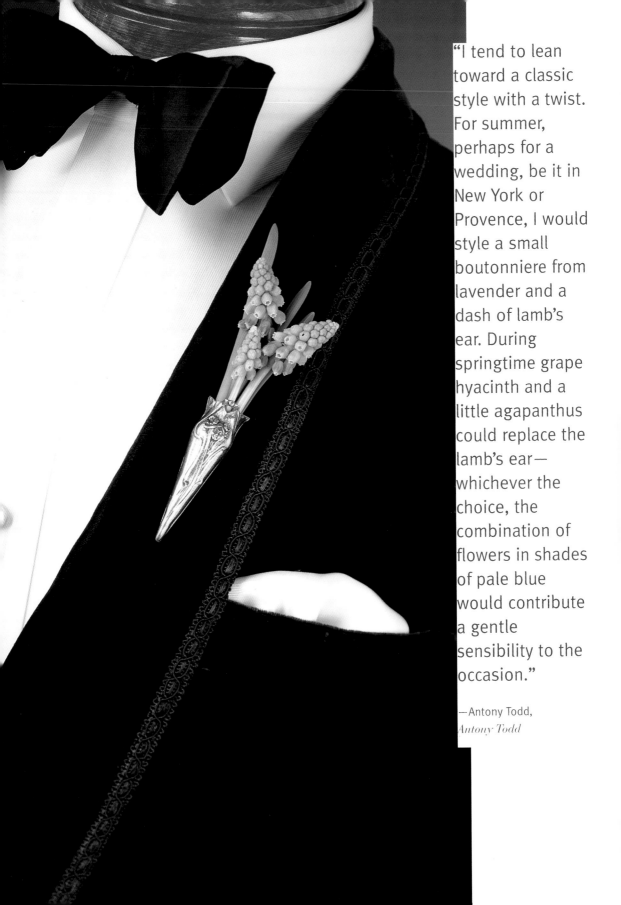

"I tend to lean toward a classic style with a twist. For summer, perhaps for a wedding, be it in New York or Provence, I would style a small boutonniere from lavender and a dash of lamb's ear. During springtime grape hyacinth and a little agapanthus could replace the lamb's ear— whichever the choice, the combination of flowers in shades of pale blue would contribute a gentle sensibility to the occasion."

—Antony Todd,
*Antony Todd*

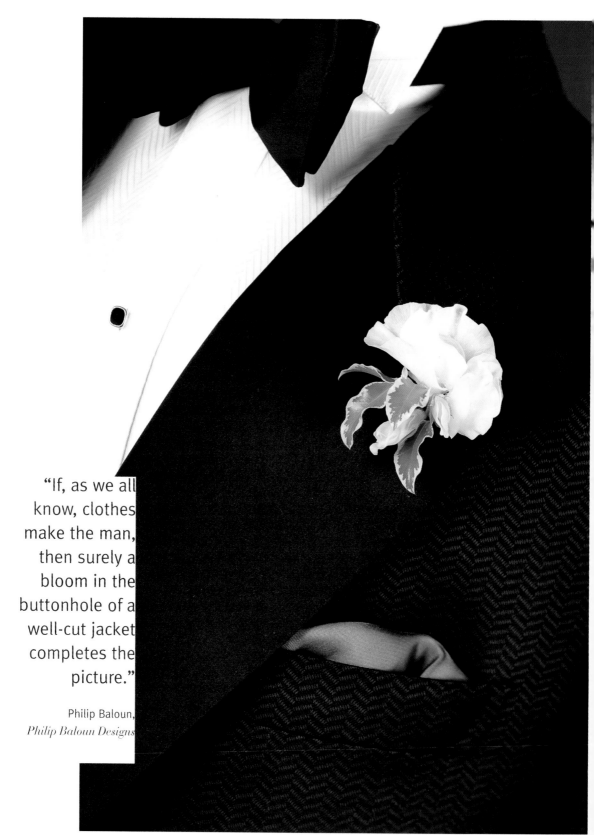

"If, as we all know, clothes make the man, then surely a bloom in the buttonhole of a well-cut jacket completes the picture."

Philip Baloun,
*Philip Baloun Designs*

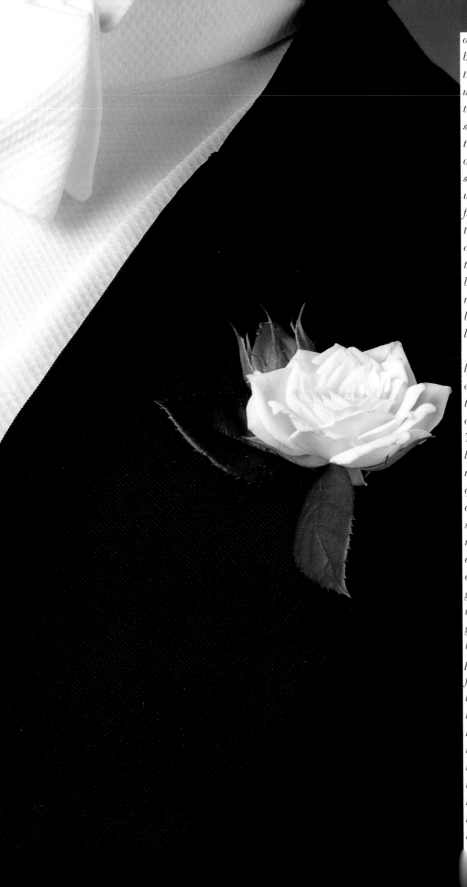

*opposite: This textured black herringbone tuxedo worn with a white herringbone tuxedo shirt adds a sophisticated twist to classic tuxedo dressing. We picked a single bloom of sweet william, a textured flower that plays up the texture of the clothes. A bit larger than the norm, this bloom is affixed neatly through the buttonhole to keep the look simple and clean.*

*left: The ultimate in evening attire, white tie and tails is classicism at its best. To accompany this look, nothing could be more fitting than the quintessential flower of all time—the rose. We selected a wendy spray rose for its delicate size and wonderful cream color set off by deep green leaves. To hold its own against such garments as these, the boutonniere must be a perfectly shaped flower; its importance lies in exquisite form, not prominent size. Like the sweet william, this rose is slipped through the buttonhole without further ado, in keeping with the pure lines of this ultra-luxe, classic dress.*

# The Language of Flowers

CYCLAMEN *diffidence*

DAFFODIL *regard*

FERN *fascination*

GENTIAN *"you are being unjust"*

GERANIUM *gentility*

HEATHER *solitude*

HIBISCUS *delicate beauty*

HONEYSUCKLE *bonds of love*

JASMINE *grace and elegance*

JONQUIL *"return my affection"*

LILAC *first emotions of love*

LILY OF THE VALLEY *return of happiness*

BEGONIA *dark thoughts*

RED CAMELLIA *loveliness*

WHITE CAMELLIA *excellence*

PINK CARNATION *woman's love*

RED CARNATION *"alas for my poor heart"*

STRIPED CARNATION *disdain*

RED CHRYSANTHEMUM *love*

YELLOW CHRYSANTHEMUM *slighted love*

WHITE CHRYSANTHEMUM *truth*

CORNFLOWER *delicacy*

RANUNCULUS *"you are rich in affection"*

RED ROSE *love*

WHITE ROSE *spiritual love*

YELLOW ROSE *diminishing love*

BRIDAL ROSE *happy love*

SWEET PEA *delicate pleasures*

RED TULIP *declaration of love*

YELLOW TULIP *"I am hopelessly in love"*

VIOLET *modesty*

# Aromatherapeutic Flowers

CARNATION *aphrodisiac*

CHAMOMILE *relaxing*

GERANIUM *balancing*

JASMINE *aphrodisiac*

LAVENDER *antidepressant*

LEMON *stimulating*

MIMOSA *relaxing*

ORANGE *stimulating*

ROSE *balancing*

VIOLET *relaxing*

YLANG-YLANG *aphrodisiac*

# National Flowers

ARGENTINA *ceibo*

AUSTRALIA *mimosa*

AUSTRIA *edelweiss*

BRAZIL *orchid*

CHILE *copihue*

DENMARK *marguerite daisy*

EGYPT *water lily*

ENGLAND *Tudor rose*

FINLAND *lily of the valley*

FRANCE *lily*

GERMANY *cornflower*

GREECE *hyacinth*

HOLLAND *tulip*

HONG KONG *Chinese orchid*

INDIA *water lily*

INDONESIA *jasmine*

JAPAN *chrysanthemum*

MALAYSIA *hibiscus*

MEXICO *dahlia*

NEW ZEALAND *icowhai*

NORWAY *purple heather*

PORTUGAL *carnation*

SCOTLAND *thistle*

SINGAPORE *orchid*

SOUTH AFRICA *giant protea*

SOUTH KOREA *rose of sharon*

SWITZERLAND *edelweiss*

THAILAND *plum blossom*

VENEZUELA *orchid*

# State Flowers

ALABAMA *camellia*

ALASKA *forget-me-not*

ARIZONA *saguaro cactus flower*

ARKANSAS *apple blossom*

CALIFORNIA *golden poppy*

COLORADO *rocky mountain columbine*

CONNECTICUT *mountain laurel*

DELAWARE *peach blossom*

FLORIDA *orange blossom*

GEORGIA *Cherokee rose*

HAWAII *yellow hibiscus*

IDAHO *syringa*

ILLINOIS *violet*

INDIANA *peony*

IOWA *wild rose*

KANSAS *sunflower*

KENTUCKY *goldenrod*

LOUISIANA *magnolia*

MAINE *white pine cone*

MARYLAND *black-eyed Susan*

MASSACHUSETTS *mayflower*

MICHIGAN *apple blossom*

MINNESOTA *showy lady-slipper*

MISSISSIPPI *magnolia*

MISSOURI *hawthorn*

MONTANA *bitterroot*

NEBRASKA *goldenrod*

NEVADA *sagebrush*

NEW HAMPSHIRE *purple lilac*

NEW JERSEY *purple violet*

NEW MEXICO *yucca*

NEW YORK *rose*

NORTH CAROLINA *dogwood*

NORTH DAKOTA *wild prairie rose*

OHIO *scarlet carnation*

OKLAHOMA *mistletoe*

OREGON *Oregon grape*

PENNSYLVANIA *mountain laurel*

RHODE ISLAND *violet*

SOUTH CAROLINA *yellow gelsemium*

SOUTH DAKOTA *American pasqueflower*

TENNESSEE *iris*

TEXAS *bluebonnet*

UTAH *sego lily*

VERMONT *red clover*

VIRGINIA *dogwood*

WASHINGTON *coast rhododendron*

WEST VIRGINIA *rhododendron*

WISCONSIN *wood violet*

WYOMING *Indian paintbrush*

Acknowledgments

Contemporary boutonnieres: photos by Robert Levin; boutonnieres created by Amy Jacobus; antique stickpins courtesy of Kentshire at Bergdorf Goodman Men.

Credits

The numbers refer to the pages. The abbreviations refer to the position of the image on the page (top, bottom, center, right, left).

24/7 Media: 58
David Bache: 60–61
Cecil Beaton, Camera Press: 35
Bridgeman Art Library: 7T, 25, Victoria Art Gallery, Bath & NE Somerset Council;
17, Rangers House, Blackheath; 29, Chalmers Bequest, Hackney; 30, Philip Mould, Historical Portraits, Ltd.
32C, Musée D'Orsay, Paris © ADAGP, Paris & DACS, London 2000;
33, Musée des Beaux Arts, Rouen, © ADAGP, Paris & DACS, London, 2000.
Brioni Archives: 42–43
British Museum, London: 28
Defence Picture Library: 36R
EON Productions Archive: 48, 49
Fondazione "Il Vittoriale degli Italiani": 26
Gale & Polden: 37R
Tim Graham Picture Library: 7R, 37L, 37C, 38, 39, 55, 63
Ronald Grant Archive: 46, 47
Hulton Getty Picture Library: 12, 34L, 36L
Kobal Collection: 44L, Columbia; 44R, Paramount; 45
Robert Levin: 6B, 8–11, 53, 57, 64–95
Metropolitan Museum of Art, Purchase Irene Lewison Bequest: 22
Museum of London: 23, 24
National Portrait Gallery, London: 6L, 16, 31L, 32T
The New Yorker Collection, Claude Smith, 1954: 96
Norton Museum of Art: 32B
Jonathan Pilkington: 62, 74
Roger-Viollet, Paris: 19, 31R
Scala/Art Resource: 14, 21
Sotheby's, London, Roger Collection: 34R
V&A Picture Library: 40
Verwaltung Schloss, Brühle: 20

*"Better get rid of it. This doesn't look like a boutonniere-type jury."*